A FRESH LOOK AT WOMEN IN MINISTRY

The Hermeneutical Oddity of 1 Timothy 2:12

WRITTEN BY KIP SMITH

EDITED BY CARI NIMETH, DMIN

ISBN: 978-1-7353813-0-5
Last Mile Books
Catonsville, MD

Kip Smith, P. O. Box 3024, Catonsville, MD 21228
Pastorkip3030@gmail.com

Edited by Cari Nimeth, DMin

Cover Design and Interior Design by tamiboyce.com

The information presented herein represents the view of the author
as of the date of publication.

Dedicated

To Debbie, my beloved, whom God used to open my mind to the ordination of women as deacons. And, a special thanks for the many hours of reading, editing and valued input.

To my Wednesday PM Bible Study group, for the hours of working through 1 Timothy 2:12 with me.

To my church staff, both men and women, who over the many years we shared ministry together, you processed with me many of the conclusions in this book; and, the sharing of your call to ordination to the gospel ministry.

Table of Contents

The Problem

How do you understand the Scripture below?

> But I do not allow a woman to teach or exercise
> authority over a man, but to remain quiet. (1 Tim.
> 2:12 NAU)

Some people answer, "It means what it says. Women in the church should not be allowed to teach a man nor fill positions of leadership, over men." Others answer, "I just can't accept it the way it is written. I can't imagine this would be God's will for women." Many just ignore the passage altogether, omitting it in sermons or Bible studies because of the difficulty of its message in the modern day.

What if the "plain meaning" of the text is obscured by the choice of words used by the translator? What if a "hermeneutical

1

oddity"[1] is present? Hermeneutics is the method we use to interpret Scripture. An "oddity" is something that is not the norm. What if there is a hermeneutical oddity present in 1 Timothy 2:12 and the oddity obscures the plain meaning of the text?

That would be a problem.

I am an "in-the-trenches" pastor of a Southern Baptist Church located in the state of Maryland. I hold a Master of Divinity degree from Southern Baptist Theological Seminary (1991). I am also a Certified Public Accountant (inactive), having practiced in that profession for almost fifteen years before I was called into ministry. I have been the pastor for almost thirty years. When I was interviewing to become pastor, I was asked if I planned to ordain women as deacons if called to the church. My response, "No. I do not, but God might. My wife is ordained as a deacon, so it seems unlikely that God would call me here if He did not likewise have that as His plan." It took about seven years before I did, indeed, ordain a woman.

When I first arrived, I noticed something that needed to change. There were no females serving in any official capacity other than working in the kitchen and writing prayer cards to the sick (both very needed in all churches!). I asked one of the spiritually mature women to become an usher. Her words shocked me, "Oh pastor, I can't do that. Women aren't allowed to serve as ushers here." I changed that.

1 The phrase "hermeneutical oddity" is taken from the Danvers Statement. See https://cbmw.org/about/danvers-statement/.

What do you do when a female minister on your staff, a gifted person as both a project manager and a worship leader, tells you that she believes God is urging her to preach sermons, and no woman has preached a sermon before in your church? Do you tell her that she *must have it wrong* because God does not call women—particularly, to preach? Then do you offer her 1 Timothy 2:12 as the basis for your statement?

How do you move forward if you are trying to hire a Minister to Children and a candidate tells you that she has the spiritual gift of leadership, but her current church does not recognize women in that capacity? If she joins my staff, will I allow her to function in ways women do not normally function (at least in the context of a Southern Baptist Church [SBC]), e.g., baptize, and officiate at weddings and funerals?

How do you respond to a candidate for your Minister of Students who, after discussing his theological basis for women in ministry, tells you he must withdraw his name from consideration because he saw your church's online worship service and a woman was preaching the sermon? Then, he tells you that the reason you interpret 1 Timothy 2:12 the way you do is because you "don't want to hear the truth." (Actually, I think he had it backwards.)

These are real-life situations for me.

Imagine how many women have been kept from serving the Lord by their well-meaning, God-loving pastors or by deacons/

elders who say, "I am sorry but I believe the Bible and I must obey what it says, even if it is hard to do so."

What if we have it wrong? What if a hermeneutical oddity is the problem?

What if the "traditional view" that denies women a role in ministry—specifically, leading or teaching/preaching roles—is wrong? What if 1 Timothy 2:12 has been incorrectly interpreted for decades and beyond? I know that may sound preposterous to many Bible-believing readers. However, is it not true that the longer we hold to a certain belief or view, the more difficult it is to change that view or to even see another option as possible?

What was it we believed about the Earth being flat?

I can imagine you thinking that 1 Timothy 2:12 is hardly comparable to believing a mistaken scientific fact; but here is my struggle: I was in the business world for around fifteen years before God called me into ministry. I have been in ministry as a pastor for double that time; and, never in this entire time did anyone tell me (nor did I read) about much of what I am going to tell you in this book. I am not saying that people did not talk about women in ministry; but never had I been told the context or the facts behind the Apostle Paul's instruction to his young protégé, Timothy. It is almost as if I were in a "bubble." I cannot help but wonder if my bubble was like many other pastors; for some reason, no one told the *whole* story about 1 Timothy 2:12 or I was just so consumed with other things, that my bubble kept me from knowing. Being called into ministry during the

height of the inerrancy battles in the SBC (mid-80's), I was ever determined that my ministry would not be consumed with denominational battles. To me, it was a waste of my calling. If it was my bubble that kept me from knowing what I now know, may the Lord forgive me! Almost ten years after becoming pastor of Bethany Lane Baptist Church in 1991, I led the church in the ordination of a woman to the gospel ministry, a step that was in violation of the SBC's "Kansas City Resolution." This resolution "encouraged the "service of women in all aspects of church life and work other than pastor functions and leadership roles entailing ordination."[2] The Kansas City Resolution passed on the floor of the 1984 Convention by a vote of 4,793 yes votes to 3,460 no votes, or 58% of votes cast.[3]

My present journey into this area was precipitated by a change in the organization model for our church. Historically, we were organized in a typical, baptistic, congregational style of governance, replete with monthly business meetings and the like. It was a recipe for disaster, with each month's business session fostering strife rather than fostering unity. The church staff began looking at different models, including an elder-led model. The issue of whether a woman could be an elder came up in our study. I realized that I was not prepared for the questions that arose in the process. Shortly thereafter, I also realized that our employment and ordination of women did not sit well with recent graduates

2 Elizabeth H. Flowers, Into *the Pulpit* (Chapel Hill, NC: The University of North Carolina Press: 2012), 102.
3 Ibid., 103.

from Southern Baptist seminaries applying for staff positions in my church. The more recent the graduate, the more likely they would take issue with our policies. I discovered a change in teaching had occurred in some Baptist seminaries. I had to figure out why and where I stood on questions I had long ago resolved.

I decided that a good way to update my understanding of this area was to teach the topic on a Wednesday night for our midweek Bible study. I chose the book of 1 Timothy. This work is the result of that study.

I also discovered that there were many renowned biblical scholars who had come to the same conclusions that I had reached in my search for truth in the area of women in ministry. Of course, there are many others that hold to the "traditional view," that women in the church should not lead men, teach men, or be ordained, and certainly they should not preach. I, respectfully, disagree, and this book is my effort to support why I disagree.

Women, "Go Home." In a panel discussion, renowned pastor, John MacArthur, was asked to give a response to the panel moderator's "one-word statement." The "one-word" statement was: "Beth Moore." After bantering jokingly and even a caution from the moderator before MacArthur gave his response, MacArthur stated, "Go home." He then followed this response (amid laughter from his audience) with, "There is no case that can be made, biblically, for a woman preacher.

Period. Paragraph. End of discussion" (applause from his mixed-gender audience).[4]

With *grudging* respect to John MacArthur (and his humiliation of people who disagree with him), this book seeks to *continue* his discussion. As a Bible-believing pastor who grew up in the Southern Baptist Church, I have a heart for the Church. I also have a heart for the leaders in God's Church and their angst over some very real problems, at least from my perspective. How can it be God's will that half of the church—the women—be omitted from the leadership roles of the Church in a time of great spiritual need not only for America, but also for the world? Where would the Church be without the women?

This book intends to give a "non-technical" view, yet supported by scholarly evidence, that refutes the "traditional" view of the "John MacArthurs."[5] I will rarely use technical terms like "complementarian" or "egalitarian" in this book. Technical terms have different meanings to different people. They tend to become labels that divide rather than unite. That said, I might summarize the two views as follows. A "complementarian" view, at its most basic level, is that God created the male as the head, and woman as his helper, in both the home *and* the church. Gender defines who is the head and who is the

4 "John MacArthur Beth Moore Go Home," YouTube, accessed May 17, 2020, https://www.youtube.com/watch?v=NeNKHqpBcgc.
5 This view is referred to by scholars as the "complementarian" view. I will refer to it as the "traditional view." The opposing view is referred to as the "egalitarian" view.

follower.[6] In this book, I refer to complementarians as "traditionalists." The traditionalists claim that their view is the "Christ-honoring, Bible-believing perspective."[7] They claim that the egalitarian perspective is the "liberal, culturally acceptable view."[8]

An "egalitarian" view, contrary to the complementarian view, is that male and female are equal in all ways, including their qualifications for leadership. Each leads in different ways based on individual talents and gifts more like a partnership with two "general" partners. For those who desire a deeper understanding of the two views, I suggest the scholarly book, *Two Views on Women in Ministry.*[9]

The heart of the division between complementarians and egalitarians in the current day has moved beyond whether a woman can *serve* in ministry. The heart of the issue is whether a woman can *lead* in ministry. May she have titles like "Reverend" or "Dr." before her name? May she possess authority over a man, including to preach (which assumes authority)?[10]

6 For a view of complementarianism see "The Danvers Statement," The Council on Biblical Manhood and Womanhood, accessed May 23, 2020, https://cbmw.org/about/danvers-statement/.

7 James R. Beck, ed., *Two Views on Women in Ministry*, Revised Edition (Grand Rapids, MI: Zondervan Publishing, 2005), 22.

8 Ibid.

9 Ibid.

10 Ibid., 21-22.

The problem is blurred by how we change language to conform to a particular view. Here is a quote to demonstrate what I am saying:

> To avoid the appearance of disobeying scriptural injunctions, women who were obviously preaching scripture—women like Kay Arthur, Jill Briscoe, and, later, Beth Moore—made a habit of calling themselves "bible teachers" instead. This was a perennial issue, one that commentators on American Christianity have long wrestled with. As the editor of The Herald and Presbyter in 1874 had opined, "She may teach in the Sunday-school, hold her Bible classes, composed perhaps of hundreds or even thousands of both sexes, lead the congregation in the service of song, etc.; in these things we are all agreed. She may not be a bishop; in that we are nearly or quite unanimous. But where the 'lecturing' ends ... and the sermon begins, is not so plain.[11]

This book is written, first, for pastors like me--"in-the-trenches" pastors, who are overwhelmed by the challenges of ministry

11 Kate Bowler, *The Preacher's Wife: The Precarious Power of Evangelical Women Celebrities* (Princeton, NJ: Princeton University Press, 2019), 24-26. Quoting: Lois A. Boyd and R. Douglas Brackenridge, *Presbyterian Women in America: Two Centuries of a Quest for Status* (Westport, CT: Greenwood Press, 1996), 97.

and for whatever reason have been unable to take the time to delve into the topic of women in ministry. Perhaps some of you, like me, are surrounded by gifted women in a time when there are never enough people resources, male or female, for the task God has called you to. Perhaps you have witnessed God bearing fruit through men *and women* and wonder how this is possible if God's will for leadership is limited to men. Jesus put it this way in John 6:31 (NAS), "If I alone testify about Myself, My testimony is not true. There is another who testifies of Me, and I know that the testimony which He gives about Me is true." If the Spirit is giving testimony through women, how can you and I, as pastors, deny the truth God is giving witness to?

I also know that unless the pastors get a different view of women in ministry, it is unlikely that any change of significance will reach the people in the pew. I know that the "John MacArthurs" among us will be unwilling to change their views, regardless of how the Spirit gives testimony. In fact, most of this group put this book down after reading the opening paragraph. How does the saying go, "There is no one so blind as he who refuses to see"? In fact, if John MacArthur's statement, "no case [can be made] for a woman to be a preacher" is true, why is God authenticating the preaching ministry of women? After all, it is not the "pulpit" that one stands behind that defines a preacher. It is the Spirit of God working in and through the speaker that defines a preacher. Women are being used as preachers, teachers, and leaders for His glory. If the correct interpretation of

Scripture is that women should not be in the preaching ministry, and God is giving testimony through them today, then God would be a liar. That is, He would be violating His own Word, and that is something we know is not going to happen. God *is doing things* through women in all ministry roles and areas of giftedness. In the process, God is receiving the glory due His precious name!

This book is written, secondly, for the women God is calling into roles typically limited to men. May you be encouraged to take steps of obedience as you listen to the Spirit of God rather than your male brothers in ministry, regardless of how genuine their counsel may be.

Do you recall the story of Jesus riding into Jerusalem on the day we celebrate as Palm Sunday? The crowds waved palms and cried out, "Blessed is the King who comes in the name of the Lord." The exchange between Jesus and the religious leaders is recorded in Luke 19:

> And some of the Pharisees in the crowd said to him, "Teacher, rebuke your disciples." He answered, "I tell you, if these were silent, the very stones would cry out." (Lk. 19:39-40 ESV)

I suggest that Jesus's reply to the Pharisees is fitting for us today. When we limit or silence those whom Christ has called to exalt and glorify His name, whether they be female or male, we

are apt to be standing against the Only Begotten One who died to set us free—from sin, from captivity, and from every human barrier that is the result of the sin of Adam. If God can make a stone cry out in praise, why can He not do the same through a woman?

• • •

In Genesis 3:15, the text states, "I will put enmity between you and the woman, and between your offspring and her offspring; he shall bruise you on the head, and you shall bruise his heel" (ESV). Each of the chapters that follow will begin and end with an example of how women are being used by our Lord to "bruise the head of the serpent." To clarify for the reader that the example provided is not directly related to the thoughts contained in the chapter, but rather stories of women used by Christ, I have set these thoughts apart from the body of the text with three dots "• • •" and entitled the example, *"Crushing the head of the Serpent...* **one example of a woman used by Christ."**

A Hermeneutical Oddity

Crushing the head of the Serpent... **one example of a woman used by Christ:**

In St. Louis, the convention center was packed with more than twenty-seven thousand women eager to see **Joyce Meyer** take the stage at her largest annual event. Joyce was one of the world's most famous Pentecostals, a televangelist whose program *Enjoying Everyday Life* was one of the most-watched Christian television programs with an estimated (potential) audience of 2.3 billion, a Twitter following of six million, and more than a hundred books in print by her thirty-fifth year in ministry. She was a prosperity preacher through and through, but a woman so powerful that famous evangelicals who

normally criticized this theology showed little compunction in headlining her conferences. When she took the stage on the opening evening, laying her Bible on the glass lectern and clearing her throat to speak, the applause from the crowd was so deafening that it took her ribbing humor to quiet them down. Her messages were almost always the same—a few verses sprinkled into an earthy and personal message about individual victory—but that did little to deter the crowds.[12]

• • •

Introduction. I wish someone had told me about that word. My favorite translation at the time, the New American Standard, gave me no hint that it was an oddity. How could I have not read about it?

As most of my readers are aware, the original manuscripts of the New Testament are written in Greek. In Greek, the word is transliterated *authentein*. This one word is the primary reason that the voices and gifts of women have been silenced by the traditionalists. The word is a one-of-a-kind word, in only one verse in Scripture. It is an oddity. I have shown one translation of the word below in italics:

12 Ibid., 24.

But I do not allow a woman to teach or *exercise authority* over a man, but to remain quiet. (1 Tim. 2:12 NAU, italics added)

The Greek word "*authentein*." As I was teaching my Wednesday evening Bible study, I was surprised by the commentary's explanation of this word. The English translation of the word was "to exercise authority" (English Standard Version). However, the New International Version (2011) translated the same word, "to assume authority." To "exercise authority" and to "assume authority" are two very different English translations of the same Greek word. The difference was significant to me, so I looked at other translations:

- KJV (1611/1764) translated *authentein* as "to usurp authority" over the man.
- NKJV (1982), NIV (1984) translated *authentein* as "to have authority" over a man.
- NIV (2011) translated *authentein* as "to assume authority" over a man.
- ESV (2011), NAS (1977), NAU (1995) translated *authentein* as "to exercise authority" over a man.

The English phrase "to exercise authority" occurred in two other verses in the NAU: Matthew 20:25 and Mark 10:42. It

also occurred two more times in the NIV: Revelation 13:5, 12. I checked the Greek word for these passages, and to my surprise, the Greek word was a different word. The Greek word was *"exousia."* Keep in mind that my search used the same English phrase, "to exercise authority"; yet, the underlying Greek word was not the same word. Why were two different Greek words translated with the same English phrase, "to exercise authority"?

I discovered that *authentein,* an infinitive verb, was present in *only one verse in the entire New Testament*: 1 Timothy 2:12.[13] *Exousia,* however, was present in many. Also, the two Greek words had very different definitions. *Exousia* meant, literally the way it was translated, "to exercise authority" in the course of a normal leadership function. For example, if you were the facilitator/leader for a small group Bible study, your leadership of the study could be described with the Greek word *exousia. Authentein,* however, is a very different word. Here is how a leading Greek lexicon defines the word:

> to control in a domineering manner – 'to control, to domineer.' ... 'I do not allow women ... to dominate men' 1 Tm 2.12. 'To control in a domineering manner' is often expressed idiomatically, for example,

13 William D. Mounce, *Pastoral Epistles: World Biblical Commentary,* Volume 46 (Dallas, TX: Word, Inc., 2000), 120.

'to shout orders at,' 'to act like a chief toward,' or 'to bark at.'[14]

Continuing our illustration, *authentein* would describe a member of the small group Bible study who takes over the group by usurping the designated leader; and, to use the Greek lexicon's definition, to do so by "shouting or barking orders at." Literally, this would be a domineering, self-willed, determined, person who usurps the existing leaders because they know better, and by golly, they are going to lead whether you like it or not. What was odd to me about the translation of the word is that *authentein* (since it was only used in 1 Timothy 2:12 in all of Scripture) should have been translated differently if for no other reason than it was only used in one verse in Scripture. How could the same English phrase be used to translate *authentein*, as was used to translate *exousia*? Taking the example just given, I would not have used the same word to describe the person who *took over* the Bible study! I wouldn't want that person to come back to the meeting!

Bible scholar, W. D. Mounce, in *Pastoral Epistles*, gives an exhaustive study of different scholars and their interpretation of *authentein*, including, "to usurp," "to tyrannize," "to control, to dominate; to compel, to influence; to assume authority over;

14 Johannes Louw and Eugene Nida, *Greek-English Lexicon of the New Testament: Based on Semantic Domains*, Volume 1 (New York, NY: United Bible Societies, 1996), 473.

to flout the authority of."[15] With this as the meaning of *authentein*, how can any translator use the phrase "exercise authority over" as the correct translation of the original Greek? Another scholar states,

> So there is no first-century warrant for translating *authentein* as "to exercise or have authority over" and for understanding Paul in 1 Timothy 2:12 to be speaking of the carrying out of one's official duties. Rather the sense in everyday usage is "to dominate," "to get one's way."[16]

If a male chair of deacons is unable to lead because a member of the board of deacons (male or female) takes over the meetings, then this would more closely describe *authentein* in 1 Timothy 2:12. If a domineering deacon (a church founder, no less) "helped" the chairperson by taking over the discussion at the monthly business meeting, this would describe *authentein*. To make it even clearer, if that "helpful" deacon had side meetings with other deacons to override the recommendation of the pastor for a change in direction for the church, that would be nearer to *authentein*. And, my friends, that is what appears to be the case for the leadership of the church in Ephesus. An

15 Mounce, *Pastoral Epistles*, 128.
16 Beck, *Two Views on Women in Ministry*, 86.

"Ephesian heresy" had taken over the church. And, the women of the Ephesian church were thought to have had some influence in the heresy. But I am getting ahead of myself. You will see this unfold in future chapters.

Extra biblical sources. Since *authentein* was used only once in the New Testament, I looked further. New Testament scholar Craig Blomberg[17] provided the following:

> In fact, all known extra Biblical instances of *authentein* (rare though they be) prior to the second century AD without exception have to do with power or domination.[18]

Blomberg summarizes the extra biblical instances of this Greek word in the following statement: The different translations of *authentein* include: "'committed an act of violence,' 'had my way with,' ... and 'dominates.'" Based on Blomberg's view, one is led to ponder how the traditionalists persist in translating *authentein* as "exercising authority in the normal course of carrying out one's official duties"?[19] A domineering, tyrannical, usurping style of leadership is not the same as "exercising one's official and normal leadership duties." Nor are "shouting" or "barking" orders the

17 Craig Blomberg is currently a Distinguished Professor of the New Testament at Denver Seminary in Colorado, where he has been since 1986.
18 Beck, *Two Views on Women in Ministry*, 95-96.
19 Ibid.

same. Clearly, the two different Greek words have two very different meanings. The traditionalist view that denies women the role of exercising authority over a man in any way does not recognize that the Greek meaning is a domineering, excessive, usurping style of leadership by someone who does not have the official capacity to lead in the first place. *That, my friends, is a problem.* Clearly, we have a "hermeneutical oddity" at work in 1 Timothy 2:12, and it appears that the "oddity" has been kept "hidden" from the people in the pews (and the pastors "in the trenches"). This Greek word has not been translated with its *best* meaning.

Paul gave the instruction because women actually were usurping male teachers. Paul's instruction that women not "usurp" men has to be considered for what it is. If there was no reason to insist women not usurp men Paul never would have given the instruction.

While editing this book, I heard a consistent loud "thud" from the area of my chimney. At first, I ignored it but then decided to walk out on the deck to find the source. It was my grandson. He was throwing his lacrosse ball against the chimney. With each thud, a catch, and then, a rapid flick of his wrist sent the ball back to the chimney. It brought me back to the days when my two sons did the same thing. I remembered the *dents* in the siding that had occurred when they had missed the chimney. I immediately called out to my grandson, "Sorry, you can't throw the ball against the chimney."

I issued the command "to stop" because an action was being taken that would cause damage to the siding on the house. My point? The only reason Paul made the instruction to "not usurp" was because the women were usurping. It was not that they were "exercising authority over men in the normal course of leadership" – they were usurping those who had been given the responsibility to lead and the responsibility to teach.

The Danvers Statement. The Danvers Statement is a key document that defines the complementarian (traditionalist) view of male and female relationships in both the home *and* the church. The opening paragraph of the document states:

> The Danvers Statement summarizes the need for the Council on Biblical Manhood and Womanhood (CBMW) and serves as an overview of our core beliefs. This statement was prepared by several evangelical leaders at a CBMW meeting in Danvers, Massachusetts, in December of 1987. It was first published in final form by the CBMW in Wheaton, Illinois in November of 1988.[20]

One of the "developments" for the writing and publication of the document is:

20 "The Danvers Statement," accessed May 23, 2020.

8. the increasing prevalence and acceptance of hermeneutical oddities devised to reinterpret apparently plain meanings of Biblical texts[21]

The problem with 1 Timothy 2:12 and the Greek word *authentein* is that the "plain meaning of the text" is completely obscured by the traditionalist view. If we translate the word "shall not exercise authority" rather than "shall not usurp or supplant authority," we have two very different meanings. The "hermeneutical oddity" is why *authentein* was not translated "shall not usurp, dominate or supplant" a man in the first place. The plain meaning of the text has actually been *obscured to the "ordinary people."* 1 Timothy 2:12 is the prevailing passage in New Testament Scripture that leads one to a complementarian view, and hence, this is a very important text. This text silences a woman and keeps her *walking behind* a man rather than beside him—in the home **and** in the church. Is it possible that our theological predisposition that a husband is the head of his home has extended to the church when it should be limited to the home?

The Statement continues with its next "development":

9. the consequent threat to Biblical authority as the clarity of Scripture is jeopardized and the

21 Ibid.

accessibility of its meaning to ordinary people is withdrawn into the restricted realm of technical ingenuity[22]

Interesting isn't it? The clarity of Scripture is actually jeopardized by the traditionalist's translation of *authentein*. The *plain meaning of the text* has actually been "withdrawn into the restricted realm of technical ingenuity" by the complementarians. Respectfully, it certainly seems to me complementarians have ignored the clearest translation of this odd word. In so doing, a theological predisposition has been revealed—a woman has an assigned place, in the home and in the church, and it is behind a man, in silence.

That is a problem for me.

Adam and Eve - why does "first bite" matter to Paul? The traditionalist view denies a woman any role in teaching/preaching/leading men. Of course, there are variations of that view both to the left and to the right. The traditionalist view offers 1 Timothy 2:13-14 as evidence that Paul's instruction is not limited to his day and time. Rather, it applies to the whole Church for all time. 1 Timothy 2:13-14 states:

But I do not allow a woman to teach or exercise authority over a man, but to remain quiet. For it was

22 Ibid.

> Adam who was first created, *and* then Eve. And *it was* not Adam *who* was deceived, but the woman being deceived, fell into transgression. (1 Tim. 2:13-14 NAU)

Why would Paul justify his instruction that a woman must not "exercise authority over a man" by bringing up Adam being created before Eve, and Eve being deceived, not Adam? *Doesn't the "apple" have two bites?*

First, how can we say that Adam was not deceived if he was standing right beside Eve when she ate of the fruit?

> When the woman saw that the tree was good for food, and that it was a delight to the eyes, and that the tree was desirable to make *one* wise, she took from its fruit and ate; and she **gave also to her husband with her, and he ate**. (Gen. 3:6 NAU, emphasis added)

The text explicitly states that Adam was "with her, and he ate." Even more to the point is that Adam and Eve experienced the loss of innocence at the same time; the "eyes of both" were opened, and "they knew they were naked" (Genesis 3:7). They hid from God, *together*, in the trees of the garden (Genesis 3:8). By their actions, we see that the "moral law," i.e., their knowledge of right and wrong (Genesis 2:17 defines the tree as the tree of

the "knowledge of good and evil) was "activated," *simultaneously.* Eve's was not activated, first, and then Adam's. How can Paul state that Eve was deceived and Adam not deceived if they both ate of the same fruit at the same moment in time, and both lost their innocence, at the same moment? Paul could not be saying a woman is disqualified from teaching /leading a man because Eve *took the first bite from the fruit.* That defies logic and the literal events of the Genesis text. Their innocence was lost, together, because their sin was committed, together, *as a couple,* and as two individuals, male and female. Paul even says as much in Romans 5:12, "Therefore, just as sin came into the world through one man, and death through sin, and so death spread to all men because all sinned—"; Eve is never mentioned, only Adam. How is Eve the one deceived and not both? *The fruit does have two bites* no matter how we explain the order of the bites; and, both were "corrected" by God for their individual acts. If both were corrected, then Paul's point cannot be that Eve took the first bite, so she has the greater punishment. If that were the case, God's punishment of both, instead of just Eve, would be unjust.

I propose that Paul's instruction in verses 13-14 supports the view that *authentein* is best translated as "to usurp, to supplant" the authority of a man. Think about life for Adam and Eve *before* that first bite. They were like two children playing in a field. One was not "leading" the other nor exercising authority over the other. They were in a state of innocence where life was defined by

the enjoyment of each other's company. At this point, the moral law had not been activated, the flesh was not in dominion, and they were like two children enjoying what God had created, one for the other.

At this point, all we know is that God had commanded Adam not to eat of the tree in the center of the garden (Genesis3:17). We also know that Adam modified God's command to not eat of the tree by telling Eve not to even touch it (Genesis 3:3). Eve *disobeyed Adam* when she touched the fruit. Adam and Eve *disobeyed God* when they ate of the fruit. But Eve went beyond disobeying Adam. She supplanted Adam; she usurped him. She replaced Adam's instruction (from God), "you will surely die" (Genesis 2:17), with that of the serpent's "you surely will not die" (Genesis 3:4). We might even say that ultimately the serpent's instruction to Eve supplanted Adam's instruction to Eve. When Adam ate, the instruction of Eve supplanted the instruction of God. The fruit of the tree now has two bites—each of which was rooted in the replacing of God's instruction with one's own, regardless of the means by which that instruction occurred.

There is an interesting parallel in the story of the twin sons of Isaac and Rebekah, Esau and Jacob. Esau was born first. Jacob was born second as he held onto the heel of his older brother, Esau (Genesis 25:26). In a moment of hunger, Esau foolishly sells his firstborn birth rights to Jacob for a bowl of red lintel stew (Genesis 25:34). Sometime later at the approaching death of

his father, Isaac, the father is deceived by Jacob (and Rebekah, Isaac's wife) into giving his blessing to Jacob instead of Esau (the firstborn). Esau's lament at the deception is expressed in the following verse:

> Then he said, "Is he not rightly named Jacob, for he has supplanted me these two times? He took away my birthright, and behold, now he has taken away my blessing." And he said, "Have you not reserved a blessing for me?" (Gen. 27:36 NAU)

Jacob legally acquired the birth rights of his brother for a measly bowl of red stew (Genesis 25:34). Yet, the *blessing* of the father was acquired by deception, not by legal payment. Isaac was blind (Genesis 27:21). He was deceived into thinking that Jacob was Esau. He blessed the second-born over the firstborn; and so, the descendants of Jacob have been the blessed sons of Abraham, Isaac, and Jacob ever since. Jacob and his descendants took the place of Esau and his descendants. Jacob stepped under the extended hand of his father, Isaac, and took what was rightfully Esau's, the blessing of the firstborn. Jacob *supplanted* Esau, although he did so wrongly.

In the same way, Eve supplanted Adam, wrongly. She stepped into Adam's rightful place. She ate of the fruit. Yet, Adam followed. Eve's actions have more to do with her taking Adam's place

than her "exercising authority" over Adam. At no point do we find Eve directing Adam to do this or that. Eve never led Adam. Eve lusted for the fruit. She "ate" what the serpent was selling, much like Esau ate what Jacob was selling. In reality, Eve believed the serpent rather than God. Eve took the place of Adam, much like Jacob took the place of Esau. She supplanted him. That is far different than exercising authority over him.

The consequence of Eve's action (Adam rules) shapes the correct interpretation of *authentein* in 1 Timothy 2:12. Eve "usurped" Adam in the Garden when she stepped in his place. Paul does not want women to do the same in Ephesus. Women were not to usurp, supplant, or override the existing male leadership, pastoral or otherwise. That did not mean that women could not serve as leaders when given that role to do so in the Church. This, in fact, is why the "Ephesian heresy" had its power. Teaching leaders of the church were supplanted by those who were not qualified to do so (1 Timothy 1:3). Their teaching was heretical; and, women were a part of the supplanting group.

Let us suppose that in a staff meeting, led by myself as pastor, I state that we do not have the funds to purchase a new synthesizer for worship. However, while shopping online, our minister of music sees one she cannot pass up. So, in spite of the fact that directions had been given that she not purchase, she purchases anyway. In doing so, she has usurped my leadership. Let us also suppose that she is leading a worship team that includes a male

pianist and she directs him to play a piece of music in a particular way. She is "exercising authority" over the male pianist in the ordinary course of her leadership; and, that leadership has been delegated by me (and the church) to her. That is not what Paul has in mind in 1 Timothy 2:12, in spite of *authentein* being translated "exercise authority over" by some English translations.

Why does "first bite" matter to Paul if the fruit actually has two bites? Because before she ate, she usurped. It is not so much about her leading Adam, as it is about taking his place; usurping him. The first bite is the natural result of having first taken Adam's spot before the serpent. When she touched, she usurped her husband. When they ate, they usurped God.

A voice from the past. If you are a Southern Baptist, you know the name Lottie Moon. Lottie Moon was an SBC missionary to China for more than 40 years around the turn of the 19th century. Every year at Christmas, Southern Baptists collect the Lottie Moon Christmas offering, designated for foreign missions.[23] Lottie Moon was a single woman, perhaps 4'3" tall, who was reared on a family plantation in Virginia. She was among a handful of women that felt God calling them to foreign missions. When she received God's call, she was teaching girls in her hometown area in Virginia. She left that position and explained her decision in this statement:

23 Regina D. Sullivan, *Lottie Moon: A Southern Baptist Missionary to China in History and Legend* (Baton Rouge, LA: LSU Press, 2011), 9.

It is my profound conviction that it does not pay a woman to give her life to teaching forty girls. I would not do it myself, nor advise any other woman to do it…. Under no circumstances do I wish to continue in schoolwork. I confess it would please my ambition to build up a big school, but I long to go out & talk to the thousands of women around me.[24]

At the time,

…female missionaries were supposed to run schools and visit women in their homes to present the gospel. They were not to move into the male domain of preaching or open evangelism of both sexes. Southern Baptist policy, at home and abroad, prevented women from speaking to groups that included men, and women **were strictly forbidden from preaching**.[25] (emphasis added)

Miss Moon was assigned to China; and later, her sister, "Eddie," joined her. Mission work in China went this way: The women would travel to a village, wait for a crowd to form, and then speak to them about Christianity. Crowds, made curious by

24 Ibid., 73.
25 Ibid., 52.

the women's strange appearance, would quickly form. In spite of SBC mission policy, the women missionaries did not separate the villagers by sex before they began talking. "Instead, they simply started 'preaching,' as they termed it themselves."[26] Moon immediately sensed how the missionaries' behavior blurred the boundaries of what was considered proper, but she was overwhelmed by her responsibility for the souls of all the people she met—not just the souls of women. After years in China and many appeals to leadership in America, Moon informed her male superior in America that she had been invited to a nearby village to speak to a hall overflowing with potential converts. She described her dilemma: "I hope you won't think me desperately unfeminine, but I spoke to them all, men, women and children, pleading with them to turn from their idolatry to the True and Living God. I should not have dared to remain silent with so many souls before me sunk in heathen darkness." Moon continued to her superior, "I halted at two villages and had an enjoyable time talking to the women. That the men chose to listen, too, was no fault of mine."[27]

It was at this point that Moon began to argue publicly that the restrictions placed on women were simply impractical and, in many cases, unjust. Her arguments brought her criticism in America for "moving beyond the woman's sphere." To her critics, Moon replied: **"It is comfortable to know that we are responsible**

26 Ibid., 47.
27 Ibid., 52.

to God and not to man. It is a small thing to be judged of man's judgment"[28] (emphasis added).

One might say that the "straw that broke the camel's back" was when Moon was informed that women were not permitted to vote in missionary meetings. Only the men were allowed to vote. After all, women were not permitted to vote at the Southern Baptist Convention meetings, so why should women be allowed to vote in missionary meetings—in China or anywhere in the world? "Think of the impact this could have in the SBC churches if women were allowed to vote in business meetings!"[29] During this period, the Women's Missionary Union (WMU)[30] was formed. Its goal was to bring women to the mission field as well as to fund mission causes of the SBC around the world. Moon was one of the women to influence American women to this end. "Many Southern Baptist men were also wondering if allowing women to form missionary societies was, in the end, such a good idea. They feared any female organization that might loosen their control and authority."[31] Rather than forfeit a woman's right to

28 Ibid., 53.

29 Ibid., 79.

30 The Women's Missionary Union (WMU) was formed by Southern Baptist women in 1888, under the leadership of Annie Armstrong of Baltimore. Its initial mission was to raise funds for foreign missions. It acted as the principal arm of Southern Baptists to that end for many years. For more than 130 years, the women that comprise the WMU have devoted themselves to foreign missions around the world. The present mission of the organization is dedicated to working with churches and believers to accomplish the mission of God. See "About WMU," Women's Missionary Union, accessed May 23, 2020, http://www.wmu.com/?q=article/national-wmu/about-wmu.

31 Ibid., 60.

vote in her missionary meetings in China, something that female missionaries had always enjoyed alongside their male missionaries, Moon submitted her resignation. She wrote, "If indeed it be their real purpose to deny to the ladies of this mission, rights that have never heretofore been questioned, then, sorrowfully, but as a matter of self-respect & duty, there can be no course open to me to but to sever my connection with the Board."[32]

Moon began to perform independent mission work, alone, in a remote area of China. This was another violation of SBC policy that required single women to live with a missionary family, headed by a man. Women were not to live or work outside direct male authority, and they were to work only with women and children. For Moon, single women, like single men, should be entitled to decide their own work, live in their own homes, and vote on mission affairs. Employing language that sounded more like that of a woman's rights advocate than a Southern Baptist missionary, Moon emphasized, "**What women have a right to demand is perfect equality**"[33] (emphasis added).

This was the essential justification for sending single women as missionaries—to reach those whom men could not. Moon had already broadened the scope of "woman's work" by speaking to men on her evangelistic trips, but her move to form her own independent mission station would make her solely responsible for all the

32 Ibid., 80.
33 Ibid., 58.

Chinese in that area, men and women alike. She was now behaving like a pioneering evangelist that, according to societal conventions and board rules, only male missionaries could be. A world away from the SBC boards and meetings, Moon now operated by her own rules of appropriate behavior. For her, only the parameters of her conscience could define a woman's proper sphere.[34]

At age forty-five, Moon had accomplished a complete reconstruction of her life, carving out a degree of independence unusual for a woman in the nineteenth century, especially a Southern Baptist woman who was supposed to defer to male authority in both church and home. ...And she relied upon her personal interpretation of God's will and proper female behavior to justify moving beyond the gendered boundaries she encountered... In the years that followed, she would use the freedom this isolated town afforded to build an independent work and create a personal mission in a place where she could finally be "responsible to God and not to man."[35]

Lottie Moon was a trail blazer for women at the turn of the 19th century, a trail that saw men and women of equal value, equal role, and equal spiritual calling. According to the traditionalist interpretation of 1 Timothy 2:12, Lottie Moon *ministered in disobedience to the word of God.* I can only conclude that the traditionalists have it all wrong. Otherwise, there would be no Lottie Moon Christmas offering for foreign missions! God would have seen to that.

34 Ibid., 62-63.
35 Ibid., 95.

Conclusion. A one-of-a-kind word translated oddly, if not incorrectly. That translation caused a fork in the road for future generations that limited the role of women in leading, teaching, or preaching in the church. In spite of that fork, God has continued to use women in ministry to advance His kingdom, in spite of the limitations placed upon them. Frankly, it is astounding what God has done through women, notwithstanding the shackles placed on them by the traditionalist's interpretation of 1 Timothy 2:12. One can only give God the glory.

• • •

Crushing the head of the Serpent... **one example of a woman used by Christ:**

Anne Graham Lotz was born to Billy and Ruth Graham in 1948. She was the second of five children born to the Grahams. She and her late husband, Dr. Danny Lotz, made their home in Raleigh, NC, where they raised three children. In Raleigh, she became involved in Bible Study Fellowship for twelve years, where her Bible study method brought revival and spiritual growth to countless people. In 1988, she left Bible Study Fellowship and founded AnGel Ministries.

Through her many speaking engagements, she has become known as one of the most influential preachers and evangelists of the modern era.

Her father, Billy Graham, called her "the best preacher in the family." She has spoken all over the world. The *New York Times* named her one of the five most influential evangelists of her generation. She has been profiled on *60 Minutes* and has appeared on TV programs such as *Larry King Live, The Today Show*, and *Hannity Live*. Her *Just Give Me Jesus* revivals have been held in more than thirty cities in twelve different countries to hundreds of thousands of attendees. Her central theme in her many speaking engagements is "to bring revival to the hearts of God's people." And, her message is consistent—calling people into a personal relationship with God through His Word. She is a best-selling and award-winning author. Her most recent releases are *The Daniel Prayer, Wounded by God's People, Fixing My Eyes on Jesus, Expecting to See Jesus*, and her first children's book, *Heaven: God's Promise for Me*.[36]

36 "About Anne Graham Lotz," AnGeL Ministries, accessed May 9, 2020, https://www.annegrahamlotz.org/about-anne-graham-lotz/about/.

The "Housewives" of Ephesus

Crushing the head of the Serpent... **one example of a woman used by Christ:**

Ten thousand women were crammed into Norfolk's biggest arena with heavy Bibles on their laps and a thick brochure for the Living Proof Live Event in their hands detailing the schedule for the April 2016 weekend. Almost every hotel room around the city had been booked for months as women drove in from across the southeast and down the eastern seaboard to hear **Beth Moore**, the Texas dynamo whose Bible studies had been bestsellers for almost two decades. Beth was the biggest name in

evangelicalism, as far as women were concerned, with 880,000 Twitter followers, a packed annual speaking circuit, and the constant promotion of her material by the largest Protestant denomination's publishing house, the Southern Baptist LifeWay. When she entered the arena, the women around me strained their necks to see the top of her blond head across the dark expanse and murmured about how Beth raised her hands in worship, how she sang along with the opening band, and how she might address them tonight. Beth hopped up on stage with open arms and a loud welcome, assuring the audience that even after nineteen years in ministry she had prepared a word for them tonight that came from her fervent prayer and diligent study.[37]

• • •

Introduction. We have concluded that the English translation of *authentein* is a hermeneutical oddity, if not a complete misinterpretation. But that conclusion, standing alone, is not sufficient to challenge the traditionalist interpretation of 1 Timothy 2:12. Are there other factors that need be considered?

37 Bowler, *The Preacher's Wife*, 21.

The "housewives" of Ephesus had a reputation that no other group of women in the New Testament possessed. Unfortunately, they distinguished themselves by their illicit behavior. In all likelihood, the women of the church in Ephesus were new believers from the Ephesian society of that day. Their behaviors were influenced by the pagan culture from which they lived. Some, quite likely, had families whose business income was attributable to sales of the trinkets of Artemis, the mythological goddess of fertility, referred to in Acts 18 and 19.

What is up with the housewives of Ephesus? Paul rebukes no other group of women in the New Testament the way he does the women of Ephesus. Here are some of the passages:

The housewives of Ephesus:

- Are weak, burdened with sins and led astray by their passions so that they are easily "captured" by the men of Ephesus. 2 Tim. 3:6
- They will not learn quietly and in submission (or the instruction to learn in quietness and submission is meaningless). 1 Tim. 2:11
- They dress provocatively and in costly attire which presumably is so significant that the impact on the men keeps them from praying. 1 Tim. 2:8-9
- Younger widows are prone to idleness, are busybodies, gossips, and teaching others to do the same. 1 Tim. 5:13

- Younger widows go from house to house talking about things improper for Paul to mention. 1 Tim. 5:13
- Younger widows are prone to sexual desires so strong that their desires lead them away from Christ. 1 Tim. 5:11
- Paul's solution for the younger widows is that they get married, bear children, and keep house. 1 Tim. 5:14
- Older widows had to meet eight specific guidelines before they could be added to the church's "list." If this is the rule, then there were older widows present who were abusing the system. 1 Tim. 5:9-10
- Some widows had already turned aside to follow Satan. 1 Tim. 5:15
- As it relates to deaconesses, women are not to be malicious gossips, temperate, and faithful in all things (interesting that all of the above condemnations for women are given as "must nots" for deaconesses, not deacons). 1 Tim. 3:11.

I compared what Paul said about the women's behaviors in Ephesus to the women in other churches. If similar characterizations were present, then the problem was not the women of Ephesus, but women in general.

Here is all I found in the remainder of Paul's letters about the behaviors of women:

- Women are to pray and prophesy only if they wear a head covering. 1 Cor. 11:5, 13.
- Otherwise, they are to keep silent in the churches. 1 Cor. 14:34
- Two women, Euodia and Syntyche, are urged to live in harmony. Phil. 4:2
- Older women are urged to be reverent in behavior, not malicious gossips, nor enslaved to wine, teaching what is good. They are urged to encourage the younger women to love their husbands and their children. Titus 2:3-4
- Because of the temptation of sexual immorality, each man should have his own wife and each woman her husband. 1 Cor. 7:2
- If a woman desires to learn, she should ask her husband her questions at home. 1 Cor. 14:35

There is no comparison to what Paul says about the women of Ephesus to any women of any other church in all of Paul's churches. *The problem has to be the women of Ephesus, not women in general.*

What about the other pastoral epistle? A pastoral epistle is a letter from one pastor to another. In this case, Paul writes two pastoral epistles to two young pastors in two different cities. The first was 1 Timothy (and 2^(nd)) written by Paul to Timothy. The second was written by Paul to Titus in

Crete[38] (the book of Titus). Pastoral epistles are unique to the churches and the pastor they are written to. Paul is the "senior pastor." He is the experienced, mature leader. Timothy and Titus are his "associate pastors," assigned, temporarily, to two churches.

One would expect that Paul would give the same or similar instructions to both Timothy and Titus. Such is not the case. Paul's instruction to Titus is *absent* of any instruction to women to not usurp or supplant the male leadership at the church (as in 1 Tim. 2:12). In fact, the only passage in Titus that deals with women is as follows:

> Older women likewise are to be reverent in behavior, not slanderers or slaves to much wine. They are to teach what is good, and so train the young women to love their husbands and children, to be self-controlled, pure, working at home, kind, and submissive to their own husbands, that the word of God may not be reviled. (Tit. 2:3-5 ESV)

The older women were "to teach what is good, and so train the young women to love their husbands and children..." If his instruction to the Ephesian women is different than the Cretan women, then the women in the two churches must be different. If

38 Crete was an island in the Mediterranean Sea.

they are different, then the problem is not women in general, but the women in the Ephesian church.

What about Paul's other churches? Does he give a similar instruction to those churches? Actually, in none of Paul's letters *to any of Paul's churches* does Paul give a "1 Timothy 2:12" instruction to women. The closest is in 1 Corinthians 14:34, where Paul tells the women in the church "to be silent" (as he does in 1 Tim. 2:12).[39] But a command "to be silent" is not the same as a command to "not usurp" the teaching of a man. The absence of the instruction in 1 Corinthians 14:34 is significant *by its absence.*

When I was a youth, I was quite prone to misbehavior in church—particularly if I were sitting next to my best bud in the balcony. All my dad had to do was give me the "look." He didn't need say a word, just a "look," and I understood—if I didn't get quiet, I would regret it when I got home. *I always went silent, immediately.* Let us suppose I misbehaved in another way. Suppose I refused to listen to my Sunday school teachers; or, even worse, I talked back to them. The punishment for talking back to my teacher and the punishment for talking in church was like night and day. They were two different misbehaviors on my part. Consequently, the punishments were not the same. Talking back to my teachers was at the top of his "no" list. The punishment was

39 Wilbur F. Gingrich, *Shorter Lexicon of the Greek New Testament*, 2nd Edition (Chicago, IL: University of Chicago Press, 1983), 29.

far more severe than talking in church. Two misbehaviors and two different punishments.

Likewise, Paul is saying one thing to the women in Corinth that is quite different from what he is saying to the women in Ephesus. The women in both churches were apparently "talking too much in church," perhaps, disrupting the service in some way. The women in Ephesus, however, were not just talking too much in church, they were usurping the leadership. Perhaps, the church was filled with "domineering" females who contributed to the spread of false teaching rampant in the church (1 Tim. 1:3). We cannot know for sure, but one thing we know is that the women of Ephesus were quite different from the women in any other congregation ministered to by the Apostle Paul. I propose the housewives of Ephesus required a specific instruction no other group of women in Paul's churches required—perhaps because of their behavior, or perhaps because of the temptations to return to their old way of life in the Ephesian culture. The point is that the context that Paul was addressing influenced greatly the specifics of the instruction Paul gave to the Ephesian church.

What about Paul's stance on women leaders in Romans 16? If Paul's instruction to women in 1 Timothy 2:12 is intended for all women for all time, we should find a similar instruction to other women in Paul's writings. Romans 16 is the encyclopedia of notable women for the Apostle Paul. It contains nothing similar to Paul's instruction to women in 1 Timothy 2:12.

In Romans 16:1-2, Phoebe, a *diakonos* of the church in Cenchrae, is commended by Paul to the church in Rome. She is to be received in a manner "worthy of the saints." The Greek word *diakonos* is translated by NAS, NAU, and ESV as "servant." Yet, the NIV, NRS, and NLT translate the word as "deacon." For Paul to specify that Phoebe is a "deacon of the church in Cenchrae" is a clear indication that he is referring to her in her official capacity as deacon, not as a servant of the body of Christ in general.[40] It is because of her official role in the church at Cenchrae that causes Paul to direct the Roman church to "receive her in the Lord." If Paul intended that women never exercise authority over men, how do we explain Paul's commendation of Phoebe to the church in Rome based on her service as a *deacon* at Cenchrae? "Deacon" is an office; and, those who hold it generally exercise authority over others, without regard to their gender.

In Romans 16:3, Priscilla and Aquila are described as Paul's "fellow workers in Christ Jesus." They are noted for having "risked their own necks" for Paul as well as the churches of the Gentiles. The couple is also noted in Acts 18:26 for correcting the teaching of Apollos who "they took aside and explained to him the way of God more accurately." If women are not to teach a man, how do we explain Priscilla as having taught Apollos?[41]

40 Beck, *Two Views on Women in Ministry*, 38.

41 I find it interesting that whenever there is a clear biblical exception to 1 Timothy 2:12's prohibition of a woman teaching a man, the traditionalists redefine what it means to "teach a man." In private sessions, women can teach a man but not in public settings. Since Priscilla taught in a private setting, that was acceptable. Either the

In Romans 16:7, "Junia" is hailed as a fellow-prisoner and outstanding among the "apostles." The Greek word used to describe her, "apostle," is the same word used to describe the original twelve disciples, so why would it not have the same meaning? The traditionalists create a "work-around" so they are not forced to conclude that a woman actually had a leadership role in Paul's day. In Greek, male and female names are defined by their endings. If "Junia" has an "s" at its end, it is male. Without the "s," it is female.[42] Traditionalists contend that an "s" was omitted from the Greek in spite of the fact that "Junias" is not documented as being used in literature of the 1st century; and, "Junia," the female, is used in over 250 instances in Rome alone.[43]

Romans 16 includes Syntyche, Mary, Julia, Tryphena, Tryphosa, and Euodia, and all are recognized as among those who support the work of spreading the gospel (Rom. 16; Phil. 4).[44] These are key workers, key leaders, that have advanced the cause of Christ and they are all female. *How is it possible that Paul would affirm them for their service if Paul's instruction in 1 Timothy 2:12 prohibited it?*

Throughout Paul's letters, women in leadership are prolific. One scholar provides the following:

prohibition applies, or it doesn't. You can't change the interpretation to make it fit your circumstance.

42 Belleville, *Two Views on Women in Ministry*, 86.

43 Ibid.

44 Bowler, *The Preacher's Wife*, 27-28.

No less than one out of every three individuals greeted [in Paul's letters] is a woman. It is the same with the rest of the NT record. Women are singled out in the early church as apostles (Rom 16:7), prophets (Acts 21:9; 1 Cor 11:5), evangelists (Philippians 4:2-3), patrons (Rom 16:2), teachers (Acts 18:24-26; Titus 2:3-5), deacons (Rom 16:1, 1 Tim 3:11), prayer leaders (1 Cor 11:5), overseers of house churches (Acts 12:12; 16:14-15; Col 4:15), prayer warriors (1 Tim 5:5), and those who were known for their mercy and hospitality (1 Tim 5:10).[45]

According to Kate Bowler, Associate Professor, Duke Divinity School, women in the early church played significant roles in leadership. She states,

Recent scholarship has suggested that women played a large part in church worship and leadership before the church moved against such practices. According to some scholars, women served as deacons, presbyters, stewards, bishops, and teachers; they sang, prophesied, preached, oversaw congregations, and administered the sacraments.[46]

45 Beck, *Two Views on Women in Ministry*, 36.
46 Bowler, *The Preacher's Wife*, 28, footnote 17: "See Kevin Madigan and Carolyn Osiek, *Ordained Women in the Early Church: A Documentary History* (Baltimore, MD:

In 1 Timothy 3:8-11, qualifications are given for deacons. In this passage, the male deacons are listed first and the women (Greek, *gune*) follow. The question is whether the women are listed as *wives* of the male deacons or whether they are *deacons* in their own right, i.e., deaconesses. Because *gune* can mean both "wife" and "woman," it is not clear whether Paul is referring to the wives of deacons or to women "deaconesses."[47] In defense of the position that they are deaconesses, when one compares the lists of qualifications for the men with the list for females, the list is identical with the exception of one item: the men are instructed not to be "greedy for gain." Both men and women are to:

- Be serious.
- Not be double-tongued (slanderers for women).
- Not be addicted to much wine (temperate for women).
- Hold fast to the mystery of the faith (faithful in all things for the women).

In the 1st century, women worked in the home almost exclusively. Men were the breadwinners. There was no need for Paul

Johns Hopkins University Press, 2005); Ute Eisen, *Women Officeholders in Early Christianity: Epigraphical and Literary Studies* (Collegeville, MN: Liturgical Press, 2000); Patricia Cox Miller, ed., *Women in Early Christianity* (Washington, DC: Catholic University of America Press, 2005); Deborah F. Sawyer, *Women and Religion in the First Christian Centuries* (New York: Routledge, 1996); and Gary Macy, *The Hidden History of Women's Ordination* (New York: Oxford University Press, 2007)."
47 Mounce, *Pastoral Epistles*, 202.

to tell the deaconesses not to be greedy for gain because most worked in the home. Greed was generally (but not exclusively) the temptation of the men because they were the ones who worked for a wage.

Why are the women in Ephesus, only, prohibited from teaching?

> But I do not allow a woman to teach or exercise author-
> ity over a man, but to remain quiet. (1 Tim. 2:12 NAU)

I have intentionally not discussed the first phrase of 1 Timothy 2:12 until after the discussion of the Greek word, *authentein*. How we interpret *authentein* impacts how we interpret "to teach...a man." The two phrases are part of one statement that Paul is making to the church. That is, "man" is the object of both "to teach" and "to exercise authority over."[48] The passage is not saying, "I do not allow a woman to teach (anyone)." Paul specifically tells older women to teach younger women in Titus 2:3-4. Therefore, the correct translation would be, "I do not allow a woman to teach a man or to usurp the authority of a man." Paul does not want the women to teach in a way that *usurps* or has dominion over a man's teaching or his existing leadership. This is supported by the presence of heretical teachers in Ephesus, and Paul's concern about their influence on the church. Paul states,

48 Ibid., 123.

As I urged you, remain at Ephesus so that you may charge certain persons not to teach any different doctrine, nor to devote themselves to myths ... Certain persons, by swerving from these, have wandered away into vain discussion, desiring to be teachers of the law, without understanding either what they are saying or the things about which they make confident assertions." (1 Tim. 1:3-4; see also 4:13, 16; 2 Tim. 4:2)

If women, only in Ephesus, are prohibited from teaching then the heretics are either women or the women have proven themselves very susceptible to being led astray by the heretics. Also, remember the earlier point: If Paul is prohibiting women from teaching men then it has to be that women were already doing so, and doing so contrary to the established doctrine of Paul through his young protégé, Timothy.

Is the spiritual gift of teaching gender-limited? If Paul's instruction to women prohibits them from teaching men, what are we going to do with the *spiritual gift* of teaching? Is the gift limited to men only? Is the gift extended to women only if a woman teaches other women or children? If the gift is limited in any way, what are we going to do with this passage?

And God has appointed in the church, first apostles, second prophets, **third teachers**, then miracles,

then gifts of healings, helps, administrations, *vari-
ous* kinds of tongues. All are not apostles, are they?
All are not prophets, are they? All are not teachers,
are they? All are not *workers of* miracles, are they? (1
Cor. 12:28-29 NAU, emphasis added)

Spiritual gifts are not limited to one gender. Spiritual gifts are given to all so that the entire Church can be involved in growing the kingdom of God, not just men. If the gifts are gender-limited, what do we do with this passage?

There is neither Jew nor Greek, there is neither slave
nor free man, there is neither male nor female; for
you are all one in Christ Jesus. (Gal. 3:28 NAU)

The spiritual gift of teaching cannot be *gender-specific or gen-
der-limited*, or we need to take Galatians 3:28 out of our Bibles.
If we interpret Paul's instruction to not allow a woman to teach mixed-gender groups, what do we do about this passage?

Let the word of Christ richly dwell within you, with
all wisdom, teaching and admonishing one another
with psalms *and* hymns *and* spiritual songs, singing
with thankfulness in your hearts to God. (Col. 3:16
NAU)

The text does not limit teaching to males; rather, believers are charged to "teach" and "admonish" one another. How would that be possible if only men were included in the charge?

The impact of "what we have always done." I propose to you what we know to be the case: "the way we have always done it" is of great influence upon our choices, decisions, and even our biblical interpretations. Jesus even describes the human condition: "And no one, after drinking old wine wishes for new; for he says, 'The old is good enough.'" (Luke 5:39 NAU). If something has always been done a certain way, it is hard to step outside that box. If we have always interpreted Scripture so that only men can serve in certain positions or possess certain spiritual gifts, then it is near to impossible for us to change that view. The view is comfortably settled in our belief system and causes us to interpret the Scriptures as we have always interpreted them. Anyone who interprets the Scripture contrary to the way we have historically interpreted it either is a heretic or doesn't believe the Bible.

In the course of my research, I was quite encouraged when I discovered that the latest version of the NIV (2011) *changed* the way the NIV (1984) had previously translated *authentein*. The more recent translation translates the Greek *authentein* as "to usurp." The 1984 NIV translated *authentein* "to exercise authority over."

Limited or universal application. Does Paul's instruction apply universally to all women in the Church across all time so that a woman should not be allowed to teach any man, in any church,

ever? And, if that is the correct view, how can any woman teach anywhere because there is always the possibility that a man might walk into the room and be influenced by her teaching?

Consider Apollos as he is instructed by Priscilla and Aquila (In the six NT passages that the couple names are mentioned, the wife's name is listed first in four of the six. Only in Acts 18:2 and 1 Corinthians 16:19 does the husband's name appear first. The listing of the wife's name first in most of the passages must be an indication of her importance in ministry, even over that of her husband.)

> He [Apollos] began to speak boldly in the synagogue, but when Priscilla [female] and Aquila heard him, they took him aside and explained to him the way of God more accurately. (Acts 18:26 ESV)

Why is Priscilla's instruction of Apollos worthy of a mention, if women were not allowed to teach men? Either a woman is allowed to teach or not. We must make the application universally true or universally false. We cannot explain away the heart of the teaching by creating exceptions to its application to make it fit our interpretation. If Paul intended the instruction to only apply in certain situations, then why did he not say so?

Mounce summarizes the universal application of the passage below:

The statement cannot be a blanket prohibition of women teaching anyone. Older women are told to teach what is good (καλοδιδασκάλους) and so train (σωφρονίζωσιν) younger women (Titus 2:3–4). Timothy has the same faith as did his mother and grandmother (2 Tim 1:5; 3:15; Paul never says they taught Timothy, but it is the apparent meaning of the text). Priscilla, along with her husband, Aquila, taught Apollos (Acts 18:26). Believers are to teach each other (Col 3:16; even in Judaism women could teach little children; Str-B 3:467). **The context thus limits the universal application to some extent.**[49] (emphasis added)

In no other verse in Paul's letters does he give a similar instruction to women. He doesn't say it in Corinth, Rome, Colossae, or any other church in Asia Minor or Jerusalem. *How is it possible that this instruction could apply to the whole Church for all time if Paul did not give the instruction to the whole Church, even in his own time?*

My story. When I was in seminary, I was the pastor of two small, very rural churches on the Indiana side of the Ohio River. Both possessed an active membership of around twenty-five. Both had one Sunday school class for men and women, and both

49 Mounce, *Pastoral Epistles*, 123.

were taught by a woman (two different locations, two different women). Is this passage telling us that these two women should not have taught a mixed-gender class?

In a sister congregation near my church, a woman teaches a mixed-gender class. The sister congregation holds to a traditional view of women in ministry, and only men serve as elders. Women are not allowed to preach. Yet, a woman teaches the mixed-gender Sunday school class. The explanation? Paul's instruction in 1 Timothy 2:12 did not prohibit a woman from teaching, only preaching.

I must say that I do not understand this one. The Greek word is *didasko,* literally to *teach,*[50] not to preach. To preach is the Greek word, *kerussow.*[51] Paul's prohibition is against women teaching, *not against women preaching.* If you hold to the traditionalist view, how can you allow a woman to teach and not allow her to preach? To change the Greek word to something it is not, is to force Scripture to fit what we want it to say. In my mind, once again, we have a "hermeneutical oddity"! I am aware of the explanation that if "no man is available" it is acceptable for a woman to teach. But Aquila (the husband) was available to teach Apollos when both Aquila and Priscilla (the wife) taught Apollos. If Paul intended that a woman not teach a man unless she was the only teacher available, we need to take Priscilla's husband out of the text!

50 Louw and Nida, *Greek-English Lexicon of the New Testament,* 412.
51 Ibid., 411.

Conclusion. There appear to be dominant, authority-stealing, usurping females in the church at Ephesus. As we will see in a following chapter, their belief system was likely impacted by the cult of Artemis that advocated female superiority over the male. Paul's instruction is intended to not permit a woman to teach in a way that usurps the teachings of the church leadership. Paul's instruction is not for the Church for all time since Paul did not apply this teaching to any church other than the church at Ephesus, in his time.

● ● ●

Crushing the head of the Serpent... **one example of a woman used by Christ:**

Phoebe Palmer (born 1806) "mother of the holiness movement," considered herself a "Bible Christian" who "took Scripture with absolute seriousness, her theology is her legacy. Considered the link between Wesleyan revivalism and modern Pentecostalism, her 'altar covenant' gave rise to denominations like the Church of the Nazarene, The Salvation Army, The Church of God, and The Pentecostal-Holiness Church."

Phoebe soon found herself in the limelight—the most influential woman in the largest, fastest-growing

religious movement in America. At her instigation, missions began, camp meetings evangelized, and an estimated 25,000 Americans converted. She herself would often preach, 'Earnest prayers, long fasting, and burning tears may seem befitting, but cannot move the heart of infinite love to a greater willingness to save. God's time is now. The question is not, What have I been? or What do I expect to be? But, Am I now trusting in Jesus to save to the uttermost? If so, I am now saved from all sin.'" [52]

[52] *Christian History* Magazine Editors, *131 Christians Everyone Should Know* (Nashville, TN: Holman Reference, 2000), 225.

The City of Ephesus

Crushing the head of the Serpent... **one example of a woman used by Christ:**

The conference founder **Jennie Allen** had a sweet, wide face framed by loose blonde waves and came across as a free spirit with a touch of revival fire. She led most of the conference, but the number of famous women who joined her onstage (or filmed additional segments backstage for the organization's later use) was what made this event so staggering. It became the Who's Who of women's ministry. HGTV star Jen Hatmaker kept the audience laughing with her goofy chatter, Pentecostal evangelist Christine Caine shouted about the power of God, and author Ann Voskamp prayed in her low, throaty voice. But

it was Jennie who ran the show. "See, girls, you are enough," Jennie said firmly. She called us "girls" throughout, drawing us all into the same intimate sisterhood in this dark auditorium. "And you have enough. But only—and hear this clearly—because JESUS. IS. ENOUGH. We do not have to keep living this way.... Repent and believe." ...

[Jennie continued...] When I asked God what [sin] to share, you know, there's so many. Which one?" she asked sardonically. "I hated the one, not because it's the worst one. I've got worse ones! I could shock and awe you." The audience laughed with her. "But this is the one that makes me cry." She was having dinner with a friend, ..., And then her friend said: "You know, Jennie, if God were going to build something that wasn't fake, that wasn't pretend humble, and that was actually really messy and broken, He would have to take a leader that actually believed she wasn't worthy. That actually believed she wasn't enough." The room filled with a deep silence. It sounded as if she had just admitted that she was not the humble, broken, and real leader that everyone thought she was. Tears welled up in Jennie's eyes at the memory. She wiped her nose and tried to keep going: "But the

sin is that I try to be. The sin is that I don't let God just be awesome. I try to be awesome too."[53]

• • •

Introduction. We have looked at the hermeneutical oddity in the translation of *authentein*. We have also looked at the problem behaviors of the "housewives of Ephesus." Is there another reason that calls into question the application of 1 Timothy 2:12 to the whole Church for all time?

Ephesus – Guardian of the temple of the great Artemis. Luke devotes almost two chapters in Acts to a riot in Ephesus caused by Paul's teaching and its impact upon the sale of silver trinkets. The riot was instigated by "Demetrius," a silversmith who "brought no small business to the craftsmen" (Acts 19:24). Demetrius states,

> … Men, you know that our prosperity depends upon this business. You see and hear that not only in Ephesus, but in almost all of Asia, **this Paul has persuaded and turned away a considerable number of people**, saying that gods made with hands are no gods at all. Not only is there danger that this trade of ours fall into disrepute, but also that the temple of the

53 Bowler, *The Preacher's Wife*, 166-167.

great Artemis be regarded as worthless and that she **whom all of Asia and the world worship** will even be dethroned from her magnificence. When they heard this and were filled with rage, they began crying out, saying, **"Great is Artemis of the Ephesians."** (Acts 19:25b-28 NAU, emphasis added)

The entire city was filled with confusion. A mob formed, and Gaius and Aristarchus, two of Paul's traveling companions, were accosted and dragged into the theater. The text states, "Some were shouting one thing and some another." A Jew named Alexander intended to make a defense but was grabbed and added to the foray. *For two hours the chant continued: "Great is Artemis of the Ephesians"* (Acts 19:34). The town clerk entered the scene and quieted the crowd with these words:

Men of Ephesus, what man is there after all who does not know that the city of the Ephesians is guardian of the temple of the great Artemis and of the *image* which fell down from heaven? "So, since these are undeniable facts, you ought to keep calm and to do nothing rash. (Acts 19:35-36 NAU)

Amazingly, the large crowd of rioters dispersed -- because of the known fact-- Ephesus was the "guardian of the temple of the

great Artemis." To the town clerk, Paul's teaching was irrelevant. This is the city of the great Artemis!

The importance of the event cannot be underestimated. Total population estimates of Ephesus range from 150,000 to 250,000. The text tells us that *the "city"* is in an uproar, not just the silversmith craft guild. The theatre that the group gathered in had an estimated seating capacity of 24,000 and was believed to be the largest in the ancient world.[54] No doubt, the reason why Demetrius led the group to the theater was because of its large size. This demonstrates the reach of the cult of Artemis upon the city, upon its citizenry, and upon their financial and business interests. The temple of Artemis, in fact, served as the banking center for all of Ephesus. Imagine the impact upon the temple if sales of Artemis's figurines were significantly impacted by Paul's teaching (as Demetrius states). Imagine the impact upon the wealth of the key powerbrokers in the city, many of whom had likely acquired their wealth from silver businesses either directly or indirectly related to the cult of Artemis. It is one thing to convert followers of Artemis to Christianity. It is quite another to *impact the income of the Ephesian elite.*

The Apostle Paul is doing far more than growing the church in Ephesus. He has engaged the forces of darkness that hold the entire city in captivity by the grasp of the goddess Artemis. This

54 Gary Gromacki, "The Spiritual War for Ephesus." *Journal of Ministry and Theology* 15, no. 2 (Fall 2011): 96.

is not a battle between Paul and Demetrius. Rather, it is a spiritual war between Satan's 24-breasted mythological creation, Artemis, and the Lord Jesus Christ. The souls of men and women held captive by the forces of darkness are the objects of the occasion.

A brief history of Ephesus. In the time of the Roman Empire the city bore the title of "the first and greatest metropolis of Asia."[55] Ephesus was the fourth largest city in the world, after Rome, Alexandria, and Syrian Antioch,[56] During the reign of the Emperor Hadrian, Ephesus was designated the capital of the Roman province of Asia. The grandeur of the ancient city is evident in the remains uncovered by archaeologists, including the "ruins of the Artemisia [the Temple of Artemis], the civic agora, the temple of Domitian, gymnasiums, public baths, a theater with seating for 24,000 (largest in the world at that time), a library, and the commercial agora, as well as several streets and private residences. Today the Turkish town of Seljuk occupies the site of ancient Ephesus. Ephesus is listed first in the cities of Asia in Revelation 2-3."[57] The commerce of the city was broad-based, including banking, fishing, and agricultural products. By the time the Apostle Paul entered Ephesus, it was well on its way to becoming one of the largest and most important cities of the Roman Empire, next to Rome itself.[58]

55 Matthew George, *Easton's Bible Dictionary* (New York, NY: Harper & Brothers, 1893), electronic edition, under "Ephesus."
56 Gromacki, "The Spiritual War for Ephesus," 77.
57 Ibid., 78.
58 Ibid.

The "myths" and "fables" highlighted in Timothy. Not only is Artemis highlighted in Acts but also in 1st and 2nd Timothy. Notice these verses that bring attention to myths and fables that Paul warns Timothy about, both of which were the foundation of the cult of Artemis:

- ...nor to pay attention **to myths** and endless genealogies, which give rise to mere speculation rather than *furthering* the administration of God which is by faith. (1 Tim. 1:4 NAU, emphasis added)
- But have nothing to do with **worldly fables** fit only for old women. On the other hand, discipline yourself for the purpose of godliness... (1 Tim. 4:7 NAU, emphasis added)
- ...and will turn away their ears from the truth and **will turn aside to myths.** (2 Tim. 4:4 NAU, emphasis added)
- But the Spirit explicitly says that in later times some will fall away from the faith, **paying attention to deceitful spirits and doctrines of demons...** (1 Tim. 4:1 NAU, emphasis added)
- O Timothy, guard what has been entrusted to you, avoiding worldly *and* empty chatter *and* the opposing arguments of what **is falsely called "knowledge"...** (1 Tim. 6:20 NAU, emphasis added)

The magic arts in Ephesus. Not only was Ephesus known for her Greek and Roman gods and goddesses, but also for magic.[59]

59 Ibid., 88.

Arnold points out the discovery of an "Ephesian Letter" that contained written magical spells:

> The reputation of Ephesus as a magical center may partly be derived from the fame of the proverbial "Ephesian Letters." These "letters" constituted written magical spells and are well attested in the literature. Ephesian Letters occurs as early as the fourth century B.C. in a Cretan tablet. The letters (or names) seem to be laden with power in the warding off of evil demons. They could be used either as written amulets or spoken charms.[60]

The extent to which Ephesus was impacted by magic can be seen in this New Testament passage:

> And many of those who practiced magic brought their books together and *began* burning them in the sight of everyone; and they counted up the price of them and found it fifty thousand pieces of silver. (Acts 19:19 NAU)

The goddess Artemis in Ephesus. In myth, Artemis (female) was the twin sibling of the male god Apollo. Her mythological

60 Ibid.

parents were Zeus and Leto. Both Artemis and Apollo were known as expert archers in mythology. Artemis was a virgin goddess and known as the goddess of hunt and animals. Among her followers were the female warriors known as "Amazons." Within the Temple of Artemis was a giant statue of Artemis. The statue was covered with twenty-four rounded objects on her chest, considered by most to be multiple breasts. The objects were believed to be symbols of fertility.[61] Artemis was the goddess who watched over nature for both humans and animals. She was the patron deity of wild animals, protecting them from ruthless treatment and at the same time regulating the rules of hunting activities for humans. She was considered the great mother image and gave fertility to humankind. In the Greek homeland, she was usually portrayed by statues as a young, attractive virgin, wearing a short tunic and having her hair pulled back on her head. In Ephesus and western Asia Minor, she was portrayed as a more mature woman. Her robe is draped in such a way as to expose her bosom, which is covered with multiple breasts, depicting her gift of fertility and nurture. Often standing beside her is a fawn or stag on each side representing her relation to the animal world. The official local statue was carefully housed in a temple honoring Artemis. Although she had no children of her own, Artemis was the goddess of birth and offspring among both animals and humans. One of her titles

61 M. G. Reddish, "Ephesus," in *Holman Illustrated Bible Dictionary* (Nashville, TN: Holman Bible Publishers, 2003), 494.

was *Kourotrophos* ("nurse of youths"). In art, she was often shown accompanied by deer, bears, or similar beasts, and myths told of her retinue of nymphs—female creatures.[62] As a virgin goddess, Artemis directed her watch over women in labor. They would call on her in their distress. Women who died in childbirth or who died suddenly of natural causes were said to have been killed by Artemis's arrows.[63]

One wonders if the reason for Paul's instruction in 1 Timothy 2:15, "But women will be preserved (saved) through the bearing of children..." is because of the pagan beliefs about Artemis. Ephesians believed she would protect them through childbirth, i.e., mothers would not perish in childbirth. Paul message might better be understood: "Don't trust in Artemis to get you through childbirth, trust in God; he will get you through it." From what we know of the mortality rate for women delivering children in the first century, delivering a child was nearly as dangerous as going to war with the Romans. Thus, Artemis was of critical importance to pregnant women. Paul is making a case that Ephesian women should put their trust completely and totally in Jesus, not partly in Jesus and partly in Artemis.

Female superiority over the male in Ephesus. In Greek mythology, the Amazons were a tribe of warrior women believed to live in Asia Minor. They were believed to be brutal and aggressive,

62 Gromacki, "The Spiritual War for Ephesus," 94.
63 Ibid., 96.

of superior strength to men, and their main concern in life was war. Amazons were said to have founded the cities and temples of Smyrna, Sinope, Cyme, Gryne, Ephesus, Pitania, Magnesia, Clete, Pygela, Latoreria, and Amastris. According to legend, the Amazons also invented the cavalry.[64]

The impact of Artemis upon the women of Ephesus is summarized by scholar Craig Blomberg:

> Why were the Ephesian women acting this way? One explanation is that they were influenced by the cult of Artemis, **where the female was exalted and considered superior to the male**. The importance of this cult to the citizens of Ephesus in Paul's day is evident from Luke's record of their two-hour chant—"Great is Artemis of the Ephesians" (Acts 19:28, 34).[65] (emphasis added)

> Another reason is Artemis's genealogy. Artemis (and brother Apollo), it was believed, was the child of Zeus and Leto (Lat. *Latona*); she spurned the male gods and sought the company of a human consort named Leimon. This is played out at the feast of the Lord of Streets, **when the priestess of Artemis**

64 Gloria Steinem, Phyllis Chesler, and Bea Feitler, *Wonder Woman* (New York, NY: Hole, Rinehart and Winston and Warner Books, 1972).

65 Beck, *Two Views on Women in Ministry*, 89.

pursues a man, pretending she is Artemis herself pursuing Leimon. This made Artemis and all her female adherents superior to men.[66] (emphasis added)

Consider the impact on new believers in the church of having grown up in Ephesus amidst the bombardment of the teaching of the cult of Artemis—that females were superior to males, that infants needed the protection of the goddess Artemis. In fact, Artemis was known as a watcher over women in labor.[67] Is it any wonder that Paul found it necessary to instruct women not to usurp the males, since this was the prevailing belief in the cult of Artemis.

The death of Timothy. When I discovered the fate of Timothy, I was shocked. Timothy, eventually rising to the role of Bishop of Ephesus,[68] died by stoning. Apparently, the Feast of the Lord of Streets was his final life event, except Timothy was not present to observe the parade but to stand against it. The historical details are contradictory depending upon which historical source one uses.[69] However, it appears that Saint Timothy, then age 80, was provoked as the parade passed him by. Perhaps it was the

66 Ibid.

67 Gromacki, "The Spiritual War for Ephesus," 94.

68 Alban Butler, ed., *The Lives of the Fathers, Martyrs, and Principal Saints* (Whitefish, MT: Kessinger Publishing, 2007), 699.

69 Cornelius Aherne, "Epistles to Timothy and Titus," New Advent, accessed May 17, 2020, https://www.newadvent.org/cathen/14727b.htm.

female chasing the man in an act of superiority; but whatever it was, Timothy, filled with the Holy Spirit, preached his final sermon that day. The spiritual battle begun many years before with the followers of Artemis could be tolerated no longer. It seems that Timothy stopped the parade and began to preach the Word of Christ to the entourage. The cultists were so provoked by his sermon that they dragged Timothy through the streets of the city, beating and stoning him along the way. I can only imagine the glee of the silver craftsmen of Artemis as they observed the spectacle—Timothy's preaching would no longer impact the sale of their precious silver crafts. I can only imagine the brutality intended by the female members of the Artemis parade as each hurled a stone at the dying Timothy as if to say, "Men are superior? Tell me who is superior now!"

Conclusion. Did the cult of Artemis have an impact on the city of Ephesus and the church of Ephesus? Timothy had given the best years of his life in trying to breach that divide. So important was the divide to Timothy that he gave his life to that end. It is almost as if, in Timothy's death, we see the extent of the spiritual battle between the followers of Artemis and the followers of Jesus Christ. To usurp existing male leadership in the church was akin to the Feast of the Lord of the Streets as the female pursued the male as they dashed through the streets. The public exhibition sought to illustrate that the female had authority, control, and dominion over the male. If you think about our first chapter,

the word *authentein* describes precisely the picture of her chase. The female is not "exercising authority over the male"; she has reversed it. That is not so much a "hermeneutical oddity," it a reversal of the roles of male and female as laid out by the Father. That is the culture that the church of Ephesus was birthed in and has struggled through its entire existence. As our Lord gave His life to birth His church so Timothy gave his life to stand for the church.

• • •

Crushing the head of the Serpent... **one example of a woman used by Christ:**

> **Aimee Semple McPherson** was born in October 1880. She was introduced to Pentecostalism through the preaching of Robert Semple, whom she married. After Semple's premature death, her ministry expanded in her own right. "Using Hebrews 13:8 ("Jesus Christ is the same yesterday, and today, and forever") as her theme, she preached that the "full menu" of Bible Christianity was available for listeners' firsthand experience. Around the country, she spoke about the lavish feast Christ offered the faithful and summoned people with the words of a familiar gospel song: "Come and dine, the

Master calleth, come and dine!" From Los Angeles in 1919, McPherson launched a series of meetings that catapulted her to national fame. Within a year, America's largest auditoriums could not hold the crowds. In 1923, she dedicated the Angelus Temple, which held up to 5,300 worshipers. A church-owned radio station was launched in 1924. In 1944, she addressed 10,000 people in the Oakland Auditorium. She died the next day of kidney failure. At her funeral, 50,000 people filed past her coffin.[70]

70 *Christian History* Magazine Editors, *131 Christians Everyone Should Know*, 196-198.

The Church at Ephesus

Crushing the head of the Serpent... **one example of a woman used by Christ:**

Like most slaves, **Harriet Tubman**—who was born Araminta "Minty" Ross—never knew her birth date. As the abolitionist and runaway slave Frederick Douglass noted, slaves knew as much about their age "as horses know of theirs," and the closest they estimated an actual birthday was whether it was near "planting-time, harvest-time, cherry-time, spring-time or fall-time."[71] We do know that Harriet was the fifth of nine children and was born in either

71 Michelle DeRusha, *50 Women Every Christian Should Know: Learning from Heroines of the Faith* (Grand Rapids, MI: Baker Books), 354. Quoting Frederick Douglass; quoted from Kate Clifford Larson, *Bound for the Promised Land: Harriet Tubman, Portrait of an American Hero* (New York, NY: Ballantine Books, 2004), 16.

late February or early March 1822, on the plantation of Anthony Thompson in Dorchester County, Maryland.[72]

As a young teenager, Araminta was hired out as a field hand on a neighboring plantation, and it was around this time that she received a near-fatal blow, intended for another slave, to her head, which resulted in frequent seizures and periods of narcolepsy for the rest of her life. Araminta's severe head injury coincided with a period of increased religious fervor. She was known to burst into raucous and excited hymn singing and praise, and she often spoke about hearing the voice of God and experiencing vivid dreams and visions that foretold the future. ... While contemporary scholars aren't sure how and where Araminta came to memorize Scripture, we do know through her own words that faith was a very personal experience for her. "When invited to join in prayers with a white master's family, 'she preferred to stay on the landing, and pray for herself.' Praying for strength to make her 'able to fight,' Tubman's pleadings became her own private rebellion," writes biographer Clifford Kate Larson.

72 DeRusha, *50 Women Every Christian Should Know*, 354.

"Later Tubman would come to believe that her repeated attempts to retrieve enslaved blacks from the South were a holy crusade."

She was clearly a woman who trusted in the Spirit of God to warn her of danger. She is quoted as saying, "When danger is near, it appears like my heart goes flutter, flutter," she said.[73] Others testified to the presence of the divine at work. "Harriet seems to have a special angel to guard her on her journey of mercy . . . and confidence God will preserve her from harm in all her perilous journeys," said Underground Railroad comrade Thomas Garrett. "I never met with any person of any color who had more confidence in the voice of God, as spoken direct to her soul," he added.[74]

As an Underground Railroad conductor, Tubman led seventy slaves to freedom and gave instructions to fifty more who traveled to freedom on their own. Her extraordinary courage and determination earned her the name Moses, after the biblical leader who led the enslaved Israelites out of Egypt to freedom.[75]

73 Ibid., 169.
74 Ibid.
75 Ibid.

"When the Civil War broke out in 1861, she realized a new role awaited her: first as a nurse serving the Union Army and later as a scout and spy, utilizing her knowledge of covert travel and her survival skills. Her reconnaissance helped Colonel James Montgomery capture Jacksonville, Florida, in 1863, and later that year, Harriet also played an integral role in the famed Combahee River Raid. On June 2, 1863, she guided three steamboats past Confederate torpedo mines to designated spots on the South Carolina shore, where hundreds of slaves waited under cover. As the steamboats sounded their whistles, more than seven hundred slaves scrambled aboard to freedom."[76]

• • •

Timothy's interim pastorate. If you were to read the book of Ephesians and compare it to 1 Timothy, you would wonder if the two books were written by the same author to the same church.[77] Consider just the opening verses of each book:

- **1 Tim. 1:2-4**—To Timothy, *my* true child in *the* faith: Grace, mercy *and* peace from God the Father and Christ Jesus our

76 Ibid.

77 Modern day scholars question the authenticity of Pauline authorship for 1st and 2nd Timothy and Titus. See "authorship" in Mounce, *Pastoral Epistles*.

Lord. As I urged you upon my departure for Macedonia, remain on at Ephesus so that you may instruct certain men not to teach strange doctrines, nor to pay attention to myths and endless genealogies, which give rise to mere speculation rather than *furthering* the administration of God which is by faith. (NAU)

- **Eph. 1:3-8**—Blessed *be* the God and Father of our Lord Jesus Christ, who has blessed us with every spiritual blessing in the heavenly *places* in Christ, just as He chose us in Him before the foundation of the world, that we would be holy and blameless before Him. In love He predestined us to adoption as sons through Jesus Christ to Himself, according to the kind intention of His will, to the praise of the glory of His grace, which He freely bestowed on us in the Beloved. In Him we have redemption through His blood, the forgiveness of our trespasses, according to the riches of His grace which He lavished on us. In all wisdom and insight... (NAU)

Notice that Paul left Timothy in Ephesus while he went on to Macedonia. Timothy was left in Ephesus so he could "instruct certain men not to teach strange doctrines, nor to pay attention to myths and endless genealogies." The extent of the "strange teachings" is described in several other passages in 1st and 2nd Timothy below:

- **1 Tim. 4:1**—But the Spirit explicitly says that in later times **some will fall away from the faith**, paying attention to **deceitful spirits and doctrines of demons...** (NAU, emphasis added)
- **1 Tim. 4:7**—But have **nothing to do with worldly fables** fit only for old women. On the other hand, discipline yourself for the purpose of godliness... (NAU, emphasis added)
- **2 Tim. 4:3-4**—For the time will come when they **will not endure sound doctrine**; but *wanting* to have their ears tickled, they will accumulate for themselves **teachers in accordance to their own desires**, and will turn away their ears from the truth and will turn aside to myths. (NAU, emphasis added)

The phrase "deceitful spirits and doctrines of demons" (1 Tim. 4:1) and "nothing to do with worldly fables" (1 Tim. 4:7) both line up with the context we have described for the city of Ephesus and the cult of Artemis in the previous chapter. The city is replete with mythological teachings and the magic arts,[78] chief among which is the cult of Artemis and her temple (Acts 18-19). Not only does Paul warn about the false and strange teachings in the cults but also an apparent and misguided devotion to athletics:

78 Acts 19:19 relates that books on magic were burned, worth 50,000 pieces of silver.

...for bodily discipline is only of little profit, but godliness is profitable for all things, since it holds promise for the present life and also for the life to come. (1 Tim. 4:8 NAU)

The Greek word in 1 Timothy 4:8 and there translated (in NAU) as "bodily discipline" is *gumnazo*, from which we get the English word "gymnasium." Ephesus was known for its emphasis upon the Greek games, and modern-day archaeology has discovered gymnasiums among the ruins of the city.[79] Apparently the Ephesians have something in common with the modern day—a fascination with athletics that has nigh replaced our amazement of God!

In addition, on more than one occasion, the Apostle Paul addresses false teachers:

- ...keeping faith and a good conscience, which some have rejected and suffered shipwreck in regard to their faith. Among these are Hymenaeus and Alexander, whom I have handed over to Satan, so that they will be taught not to blaspheme. (1 Tim. 1:19-20 NAU)
- But avoid worldly *and* empty chatter, for it will lead to further ungodliness, and their talk will spread like gangrene. Among them are Hymenaeus and Philetus, *men* who have

79 Reddish, "Ephesus," 494.

gone astray from the truth saying that the resurrection has already taken place, and they upset the faith of some. (2 Tim. 2:16-18 NAU)

The sum of verses has come to be described as the "Ephesian heresy."[80] For example, they have "wandered away from the faith,"[81] "paying attention to deceitful spirits and the doctrines of demons";[82] the faith of some has been "shipwrecked,"[83] some devote themselves to myths,"[84] some are "teaching a different doctrine,"[85] some are holding to what is "falsely called knowledge,"[86] some are "always learning and never able to come to the knowledge of the truth."[87] Some taught that marriage "should be forbidden" as well as that certain "foods should be abstained from."[88] Lastly, some "will not endure sound doctrine, but wanting to have their ears tickled will accumulate for themselves teachers in accordance to their own desires."[89]

There is no other book in the New Testament that has as much content focused on false teachers. Because 20% of the book of 1

80 Mounce, *Pastoral Epistles*, LXIX.
81 1 Tim. 4:4
82 1 Tim. 4:1
83 1 Tim. 1:19
84 1 Tim. 1:4; 4:7a
85 1 Tim. 6:3
86 1 Tim. 6:20
87 2 Tim. 3:7
88 1 Tim. 4:3
89 2 Tim. 4:3-4

Timothy focuses on women,[90] the Ephesian heresy has been interpreted by many to be directed at the women.

What is amazing about the church in Ephesus is how the church has "fallen" from the description, the instruction, and the beauty of the words in the book of Ephesians. In the book of Acts, Paul even warns the leaders of the church that a heresy was coming:

> From Miletus he sent to Ephesus and called to him the elders of the church. ... "I know that after my departure savage wolves will come in among you, not sparing the flock; and from among your own selves men will arise, speaking perverse things, to draw away the disciples after them. Therefore be on the alert, remembering that night and day for a period of three years I did not cease to admonish each one with tears." ... And they *began* to weep aloud and embraced Paul, and repeatedly kissed him... (Acts 20:17-37 NAU)

We find another indication of the spiritual condition of the church in the Revelation:

> "To the angel of the church in Ephesus write: 'The words of him who holds the seven stars in his right

90 Belleville, *Women Leaders and the Church*, 99.

hand, who walks among the seven golden lamp-stands. [2] "'I know your works, your toil and your patient endurance, and how you cannot bear with those who are evil, but have tested those who call themselves apostles and are not, and found them to be false. [3] I know you are enduring patiently and bearing up for my name's sake, and you have not grown weary. [4] But I have this against you, that you have abandoned the love you had at first. [5] Remember therefore from where you have fallen; repent, and do the works you did at first. If not, I will come to you and remove your lampstand from its place, unless you repent. [6] Yet this you have: you hate the works of the Nicolaitans, which I also hate. (Rev. 2:1-6 ESV)

There are two relevant groups mentioned in the text of Revelations:

- the "false teachers who call themselves apostles but are not," and
- the Nicolaitans.

It is quite likely that the false teachers mentioned are the same mentioned in 1 Timothy 1:3 as above quoted. There is little clarity on the identity of the Nicolaitans. Regardless, the church has

"abandoned the love" she had at first. Why is this significant? Because it is another reason that adds to a unique spiritual struggle at the church in Ephesus – and the necessity of the Apostle Paul to give it instructions unique to this church and not the whole of churches that Paul ministered to.

Conclusion. We have looked at the one-of-a-kind word used by Paul and its odd translation, as well as the illicit behaviors of the "housewives of Ephesus. The women, the city, the mythological culture, and the church were just as unique. All of these factors add to the conclusion that the instruction of Paul in 1 Timothy 2:12 is context-specific and not intended for the Church for all time.

• • •

Crushing the head of the Serpent... **one example of a woman used by Christ:**

Teresa of Ávila was born in central Spain. The early years of her life were without spiritual meaning. At age 21, against her father's wishes, she professed vows as a Carmelite nun at the Spanish Convent of the Incarnation in Ávila. The Convent Teresa lived in was not a stringent retreat, and she struggled spiritually. It was a serious prolonged illness

(and partial paralysis due to a supposed cure) that forced her to spend three years in relative quiet, during which time she read books on the spiritual life. After recovery, she returned to the convent life amid a waffling of convictions spiritually. She wrote in her autobiography, "I voyaged on the tempestuous sea for almost twenty years with these fallings and risings. Then, one day while walking down a hallway in the convent, her glance fell on a statue of the wounded Christ, and the vision of His constant love throughout her inconstancy pierced her heart. Gently but powerfully, she said Jesus began to break down her defenses and reveal to her the cause of her spiritual exhaustion: her dalliance with the delight of sin."[91] She immediately broke with her past, undergoing a final conversion. After this, she began experiencing profound mystical raptures, though these soon passed. For the rest of her life, she gave herself completely to her spiritual growth and the renewal of the Carmelite monasteries.

On May 28, 1577, Teresa received an inner urging to write *The Interior Castle*, her most famous literary

91 *Christian History* Magazine Editors, 131 *Christians Everyone Should Know About*, 266.

work. The central concept of the book was based upon Jesus's statement in John 14, "In my father's house are many mansions and I go there to prepare a place for you..." She used the metaphor of the castle to describe the character of Christian spiritual life; it is an interior castle, composed of rooms, the innermost of which is indwelt by the Holy Spirit.[92]

For Teresa of Ávila, prayer was the essence of Christian life and the wellspring of all moral virtues. Prayer was not everything, but without prayer, nothing else was possible. Spiritual progress has measured neither by self-imposed penance nor by the sweetest pleasures of mystical experiences but by growth in constant love for others and an increasing desire for the will of God. In her last years, her health suffered once again. On a final mission of service, her body exhausted, Teresa died reciting verses from the Song of Songs.[93]

92 John R. Tyson, *Invitation to Christian Spirituality: An Ecumenical Anthology* (New York, NY: Oxford University Press, 1999), 255.

93 *Christian History* Magazine Editors, 131 *Christians Everyone Should Know About*, 264-269.

An Appointed Time

Crushing the head of the Serpent... **one example of a woman used by Christ:**

> "I have given up my rights. I have given up my position. I have given up everything for Jesus. I have given up my desires. I have given up even my future. At that moment, when they come and rape me, I will close my eyes and say, 'Now I offer my body as a living sacrifice for You,' as it says in Romans 12:1."[94]

The above quote is taken from *Sheep Among Wolves*, by Dalton Thomas and Joel Richardson. Under threat of loss of life, women are reaching Muslims in Iran

94 "Sheep Among Wolves: Volume One," Dalton Thomas and Joel Richardson, YouTube, accessed November 23, 2019, https://www.youtube.com/watch?v=Ndf8RqgNVEY.

in the power of the Holy Spirit. Without a building, an organization structure, or a hierarchy, the church is growing at a pace likened to the first century Church.[95] And, it is growing through the ministry of *women* meeting in small groups, in homes; all the while the men are working and not part of the divine effort. Clearly, **female believers in Iran** are speaking under divine influence and inspiration. How can one explain what is happening in Iran apart from the indwelling presence of Christ?

<p style="text-align:center">• • •</p>

Introduction. We have offered an interpretation of 1 Timothy 2:12 that is based upon an odd translation of a unique word as well as unique circumstances and context of the Ephesian church. We have interpreted those unique circumstances and context to be the reason why Paul gave the instruction that he did to the church—an instruction that is limited to the Ephesian church and not to the Church for all time.

But what if our interpretation is wrong?

Suppose Paul's instruction is not context-specific, and he *did intend* that women in the church were not "to exercise authority over men" whether as a teacher, a preacher, or in the office

95 Ibid.

of deacon or elder? For those who believe the Bible to be God's inspired, inerrant word, we cannot dismiss any passage nor hold one passage "over" another simply because there are more passages like it than another. We have said that 1 Timothy 2:12 is the *only* verse in all of Paul's letters that explicitly prohibits women in the use of their spiritual gifts in ministry.[96] As a stand-alone passage, it is still the word of God. It is inspired Scripture, applicable to the whole Church for all time. But what if the passage contradicts another passage?

We know Scripture is inerrant, so either we are misinterpreting one of the passages or the Bible is not inerrant. *That certainly is not my view.* Let us suppose that both passages are correctly interpreted but each passage applies to a different time. Suppose the modern day is a specific time in human history that brings with it a different instruction; that is, it is an "appointed time," a time when God does something different and something that must be governed by different instructions. What could possibly fall into this category? I suggest *prophetic Scriptures* specifically applicable to the *last days* is the only answer.

The prophecy of Joel 2. Fifty days after the resurrection of our Lord, an event happened that literally gave birth to the Church of Jesus Christ. Jesus's Galilean followers, now comprising 120 in number,[97] were all together. Suddenly, a sound like a mighty rush-

96 Beck, *Two Views on Women in Ministry*, 224.
97 Acts 1:15

ing wind occurred, and "tongues of fire" rested on the believers gathered. This group began to speak in "tongues," i.e., in languages different from their native tongue, and languages that happened to be the languages of foreigners in proximity to the group. The foreigners were so perplexed that they concluded the group was drunk. Peter spontaneously responded by offering a spiritual explanation: "It is not because they are drunk, it is only 9a in the morning; rather, this is what was spoken of by the prophet Joel:[98]

'AND IT SHALL BE IN THE LAST DAYS,' God says, 'THAT I WILL POUR FORTH OF MY SPIRIT ON ALL MANKIND; AND YOUR SONS AND YOUR DAUGHTERS SHALL PROPHESY, AND YOUR YOUNG MEN SHALL SEE VISIONS, AND YOUR OLD MEN SHALL DREAM DREAMS; EVEN ON MY BONDSLAVES, BOTH MEN AND WOMEN, I WILL IN THOSE DAYS POUR FORTH OF MY SPIRIT And they shall prophesy." (Acts 2:17-18 NAU)

An appointed time. The "last days" in Scripture refers to a specific period of time when God will fulfill certain prophecies *not-yet* fulfilled. The last days are different from any other time in biblical times, and prophecies of the last days are fulfilled in these

98 Acts 2:14-16

days that are not fulfilled in any other time. In Acts 2:17-18, Peter links the last days' prophecy of Joel 2:27-28 with the outpouring of the Holy Spirit at Pentecost. The prophecy states, "It shall be in the last days..." By implication, the prophecy *only* applies in the last days. If you apply it one-step further, the implication is also that there will be times "within the last days" that the prophecy will be changing, continually, ever moving forward until its complete fulfillment. The fulfillment will be in stages rather than a one-time, immediate application. In the same way that birth pangs intensify as delivery nears, so the prophecy intensives as it approaches the end-of-days. This is precisely the case for Daniel 9:24-27 and the seventy-sevens of years that include the birth of Jesus in the time of Herod, as well as the "abomination desolation" that is "poured out" upon the desolater at the end of time. This particular prophecy even includes a "paragraph" or gap of time between the different steps of its fulfillment.

In Acts 2:17, Peter declares that the fulfillment of Joel 2 has begun. The "last days" are "triggered" by the outpouring of the Holy Spirit at Pentecost.[99] That is, the "starter's gun" has sounded, and the *race* to the last day of this age has begun. The race will continue for many decades, even centuries, until every prophecy of Scripture is fulfilled, the climax of which is the return of Jesus Christ, the second time, in judgment, and the

99 Heb. 1:2

ushering in of the next age, the 1,000-year reign of Christ, the Millennium.[100]

The shocking news of Acts 2:17-18. There are separate and relevant prophecies within the Joel 2 prophecy. We will look at two of them, both of which would have been shocking to the hearers of Peter's day. The first is "I WILL POUR FORTH OF MY SPIRIT ON **ALL MANKIND.**" The second is "your sons and **your daughters** shall prophesy... even on my bondslaves, both men **and women**, I will pour forth of my Spirit and **they shall prophesy**" (emphasis added).

The events that transpired after Peter spoke the Joel 2 prophecy reveal that Peter did not grasp the present reality of what he had just spoken, even though inspired by the Holy Spirit to speak the words.[101] In fact, Peter did not comprehend what it meant for "all mankind" to receive the Holy Spirit—nor did anyone gathered. At that moment, Peter, a Jew, could not imagine that Gentiles were "eligible" to receive the Holy Spirit. Gentiles were "unclean." Jews could not associate with Gentiles or they would be rendered, ritually, "unclean."

Acts 10 tells the story of Peter's revelation that Gentiles were to receive Christ as Joel 2 prophesied. Peter becomes sleepy one day around noon. He heads to his roof for a nap and there falls into a "trance." From the sky, an object like a great

100 Rev. 20:2.

101 This is similar to the disciples who did not grasp the meaning of Jesus words that He was going to the cross and would be raised on the third day (Mark 9:31-32).

white sheet comes down from heaven, full of unclean animals. Peter hears a pronouncement, "Get up, Peter, kill and eat!" The Old Testament Scripture would not allow Peter to eat unclean animals, so he refuses. The pronouncement is then followed by the statement, "What God has cleansed, no longer consider unholy" (Acts 10:15). A few days before, a God-fearing, Gentile man, Cornelius, has a dream. In the dream, Cornelius is directed to summon Simon from Joppa to his house to hear a word from the Lord. Cornelius sends his men to Joppa to find Simon. As Simon Peter wakes from his dream, the men are knocking at his door, asking that he return with them to Cornelius's house. Peter *goes*—only because Peter believes God has spoken to him through his trance (*not through the Joel 2 prophecy he has proclaimed some days before*). In Peter's going to the home of a Gentile, the first Gentiles hear the gospel and receive the Holy Spirit. The precise moment is beautiful:

> While Peter was still speaking these words, the Holy Spirit fell upon all those who were listening to the message. All the circumcised believers who came with Peter were amazed, because the gift of the Holy Spirit had been poured out on the Gentiles also. (Acts 10:44-45 NAU)

Then Peter speaks:

"Surely no one can refuse the water for these to be baptized who have received the Holy Spirit just as we *did*, can he?" And he ordered them to be baptized in the name of Jesus Christ... (Acts 10:47-48 NAU)

Notice, in Peter's trance, Peter refused to eat the unclean foods. Upon arrival in Cornelius's home, Peter describes his struggle in even entering the home:

And he said to them, "You yourselves know how unlawful it is for a man who is a Jew to associate with a foreigner or to visit him; and *yet* **God has shown me that I should not call any man unholy or unclean.**" (Acts 10:28 NAU, emphasis added)

In spite of the fact that Peter had already been directed by the Holy Spirit that the *appointed time* for Joel 2 had begun at Pentecost, Peter did not "get it." Only in Peter's trance did he hear the word from the Lord, "What God has cleansed, no longer consider unclean." Peter had failed to connect the words he spoke in Acts 2 with the Gentiles receiving the Spirit. He did not act upon the "open door" to the Gentiles until God literally pushed him through it.

Is the same thing happening today? Has the era *of 1 Timothy 2:12 closed*, and another era begun, the era wherein women walk alongside men in ministry, rather than behind them in silence?

The second prophecy – "Your daughters shall prophesy." The second prophecy of Acts 2:17-18 is that "your sons and your daughters shall prophesy." This prophecy is especially relevant to 1 Timothy 2:12. Consider the following:

The Joel 2/Acts 2 prophecy requires:

1. That men **and** women will "prophesy";
2. That men and women will "prophesy" **alongside** one another, i.e., women will not prophesy "**behind**" men but **beside** them;
3. That women will **no longer be required to be silent** because a man is present;
4. There will be no **gender-based distinction** for the "bondservants" of the Lord, **all of whom**, both men and women, will prophesy.
5. There will be no gender-based distinction for authority or office. **Everything will be equal for male and female in the last days**, whether it relates to the use of spiritual gifts, or one's role or office.[102]

Do you remember the quote from Lottie Moon at the close of the first chapter? Miss Moon stated, "What women have a right

102 I am certainly aware that the passage does not specifically address function or office. What the passage does do is communicate a "walking alongside" of male and female in the last days. This does not mean that there is no one who serves in an office or role. It just means the choice of that person must not be determined on the basis of gender, as is the case at present.

to demand is perfect equality."[103] Does Miss Moon's statement not mirror precisely the prophecy of Acts 2:17-18, a perfect equality, without distinction for gender? You and I both know that Miss Moon's "perfect equality" has nothing to do with the erasing of gender differences as modern-day feminists currently advocate. Miss Moon is referring to equality in ministry and in roles of leadership in ministry. That is what Acts 2:17-18 is referring to as well.

But what about 1 Timothy 2:12? How does Miss Moon's statement line up with 1 Timothy 2:12?

> But I do not allow a woman to teach or exercise authority over a man, but to remain quiet. (1 Tim. 2:12 NAU)

Honestly, if one holds to the traditionalist interpretation, it is impossible for Acts 2:17-18 and 1 Timothy 2:12 to be followed simultaneously. The traditionalist view denies women the right to walk alongside men as teachers, preachers, and leaders. *They must walk behind men in silence.* The only way these passages do not contradict one another is if there is a separation of time between the application of each. That is, there must be a chronology of application. One must cease so that the other can begin. *A woman cannot prophesy alongside a man while at the same time being silent behind him.*

103 Sullivan, *Lottie Moon*, 53.

Another very important point: *Peter makes a word change when he quotes a part of the prophecy of Joel 2.* Compare the two passages:

Even on the male and female **servants** I will pour out My Spirit in those days. (Joel 2:29 NAU, emphasis added)

EVEN ON **MY BONDSLAVES**, BOTH MEN AND WOMEN, I WILL IN THOSE DAYS POUR FORTH OF MY SPIRIT And they shall prophesy. (Acts 2:18 NAU, emphasis added)

The prophecy in Joel 2:29 refers to "**the male and female servants**," i.e., the *household slaves* in the Joel 2 prophecy. In Acts 2:18 (NAS), however, Peter does not refer to *household slaves* but to "*bondslaves.*" *Bondslaves* in the New Testament are believers in Jesus Christ who obey God rather than men (Galatians 1:10), not household servants. Also, "bondslaves" must refer to a more mature believer, not just any believer. Bondslaves as a group (Acts 2:18) are separate from "all flesh" in Acts 2:17. I propose the "bondslaves" are the leaders in the faith; and, the male and female bondslaves are prophesying alongside one another, not female behind male, in silence.

What does it mean to "prophesy"? Perhaps you are saying, "What does it mean for men and women to 'prophesy'? That can't

be the same as 'preaching,' because I have always been told that only men can be preachers."

Actually, I think the spiritual gift of prophecy is *representative* of all the spiritual gifts, including preaching. The reason is that Paul refers to it as the gift most desired:

> Pursue love, yet desire earnestly spiritual *gifts*, but especially that you may prophesy. For one who speaks in a tongue does not speak to men but to God; for no one understands, but in *his* spirit he speaks mysteries. But one who prophesies speaks to men for edification and exhortation and consolation. (1 Cor. 14:1-3 NAU)

A leading Greek lexicon defines the Greek word translated "prophesy" as follows:

> Προφητεύω [prophetuo]: to speak under the influence of divine inspiration, with or without reference to future events....[104]

This is the same Greek word translated "prophesy" in Acts 2:17-18.[105]

104 Louw and Nida, *Greek-English Lexicon of the New Testament*, 439.
105 Be certain not to overlook the fact that Paul specifically says in 1 Corinthians 14:3 that "the one who prophesies speaks **to men** for edification..." (emphasis added).

If Paul labels this gift as the most desirable, and Acts 2:17-18 declares that this gift will be in possession of both men and women in the last days, then before the Second Coming of Jesus, women must function in this role, i.e., by using the most desired spiritual gift, alongside men who are similarly using the gift.

How does Paul define the word? Paul defines "prophesy" as "edification, exhortation, and consolation" (1 Cor. 14:3). This definition could just as easily be used to describe the gift of teaching which Paul prohibits to women in 1 Timothy 2:12 ("I do not permit a woman to teach..."). And, since we know that Scripture does not contradict itself, then the two passages have to have two different times of application.

What about teaching with authority? Some traditionalists say that the spiritual gift of "prophesying" is not the same or equal to "preaching." Preaching *assumes* authority and, as such, is a gift restricted to men because only men have authority in the church.

First, nowhere in Scripture does it say that only men are to preach[106] (unless we interpret 1 Tim. 2:12 as referring to *preaching*

Combining Acts 2:17-18 with 1 Corinthians 14:3 leads us to conclude that *men and women*, in the last days, shall speak to **men** (not just to women).

106 Craig Blomberg states: "On the other side, many complementarians, having decided that the office of pastor-elder is limited to men, often jump to the conclusion that therefore women should never preach in a worship service. **But what Biblical text ever limits preaching to pastors or elders?** Noncharismatics typically equate the spiritual gift of prophecy, at least in part, with Spirit-filled preaching... But the spiritual gifts (charismata) are given indiscriminately by God, apart from gender, as he sees fit (1 Cor. 12: 11). And 1 Corinthians 11:5 presupposes that women can prophesy when they show appropriate submission to their spiritual heads..." (emphasis added). Beck, *Two Views on Women in Ministry*, 126.

even though the word in the text is *didasko*, "teaching").[107] Are we saying that men and women can prophesy, but only men can preach, even though prophesying is the most desired gift according to Paul, and defined by Paul as "for edification, exhortation and consolation" (1 Corinthians 14:3)?

Perhaps, again, we are hung up on *authority* being given to women. That is, when a man speaks, he does so with the authority given him by God, and God intends that only men have such authority in the Church. When a woman speaks, she does not speak with authority because only men have authority. Actually, that is a very circuitous way to attempt a resolution of the question; and it is without logic. The founding argument depends only upon itself as the basis for its answer.

How could it be possible for a woman to "prophesy" without having the accompanying authority to do so? To put it another way, how can a woman *"speak under divine influence and inspiration"*[108] without that speech being with divine authority? Divine authority is presumed by anyone who is filled with the Holy Spirit and speaking on behalf of the only Begotten Son, Jesus Christ. As stated in the opening chapter, what makes someone a preacher is not the pulpit they stand behind but the Spirit speak-

107 First Corinthians 14:34 states that the "women are to be silent" in the churches. This instruction has nothing to do with Paul's intention to limit the spiritual gift of preaching to men. Rather, it deals with a woman's behavior in the church while another is teaching/preaching. In fact, a woman could be teaching and the instruction by Paul still be interpreted to apply to the behavior of women in the "pews."

108 Louw and Nida, *Greek-English Lexicon of the New Testament*, 439.

ing through them. Lottie Moon described men listening to her "sermon" in this way: "That the men chose to listen, too, was no fault of mine."[109] They listened because they were fed of the Lord. That can only happen when someone is speaking on behalf of our Lord as His messenger. The Apostle Paul puts it this way:

> For we speak as **messengers approved by God** to be entrusted with the Good News. Our purpose is to please God, not people. He alone examines the motives of our hearts. (1 Thess. 2:4 NLT, emphasis added)

Paul says that God entrusts His "approved messengers" with the Good News. Approval by God and entrustment with the good news are opposite sides of one very valuable "coin." When I was called into ministry at age 37, the evidence to me of my calling was *not* that I was a gifted speaker, i.e., that I had talent as a public speaker (my DNA). Rather, it was that God changed people's lives through my words. When I taught the Bible, people were fed, spiritually. When I gave testimony about Jesus, people were saved. That changed my life and changed what I wanted to do for the rest of my life. I left a six-figure income not because my work did not fulfill me; it did. When God began to use me to transform people's lives for eternity that was of far greater worth to me. *That changed*

109 Sullivan, *Lottie Moon*, 82.

me. It changed what I wanted to do. I wanted to tell people about Jesus more than I wanted to advise them on taxes. *That was my miracle!* His call became my life purpose and I never looked back.

Likewise, women who are speaking as God's messengers are doing so because God is changing people's lives through their words. They are speaking because God has called them and they have responded, regardless of whether the traditionalists approve or not. They can no more deny that call than I could deny mine. God is blessing the work of women in the modern day; and if God is blessing it, the work is under His divine influence, authority, and His approval. Whether or not the "John MacArthurs" recognize them is irrelevant.

What about a woman filling an office in the church? The same logic has to follow for the role of an office in the church. The spiritual gift of prophecy is given to both men and women in the end-of-days. They walk alongside each other in the use of the gift. The gifts are not given to one person or gender but to the whole of the body of Christ so that the body of Christ forms a united whole. Each gift "possessor" uses his or her gifts for the benefit of others. The Holy Spirit sees all persons of equal worth and value so that the body of Christ can function as one body. The Apostle Paul puts it this way:

> On the contrary, it is much truer that the members of the body which seem to be weaker are

necessary;[23] and those *members* of the body which we deem less honorable, on these we bestow more abundant honor, and our less presentable members become much more presentable, [24] whereas our more presentable members have no need *of it*. But God has *so* composed the body, giving more abundant honor to that *member* which lacked, [25] so that there may be no division in the body, but *that* the members may have the same care for one another. (1 Cor. 12:22-25 NAU)

For much of the last 2,000 years, women have been our "less presentable members" of the body. We are called to give "more abundant honor to that member which lacked," not less honor. The current interpretation of 1 Timothy 2:12 does precisely that— it gives less honor to the "less presentable" member of the body. Because of gender, women are expected to be silent, quiet, and walk behind men. How does that give more abundant honor to "that member which lacked"?

But shouldn't men be the leaders in the body of Christ, particularly for deacons and elders? Yes—*if they have the spiritual gift of leadership, but not because they are male.*

A woman as pastor? I must say that this is the one area I have struggled with the most. A woman as pastor? My personal history in the Church has not allowed such. Yet, I wondered if my

inability to cross this last threshold was because of how I had always viewed a woman's role in the church—all roles and offices are open, except the lead pastor. This was supported, further, by 1 Timothy 3 regarding "overseers," where only men are listed as potential qualifiers. This is in contrast to deacons where both men and women are listed as potential qualifiers. My conclusion has always been that only men can serve as the pastor/elder.

Yet, I have concluded that we are in the end-of-days and that Acts 2:17-18 is the applicable passage for this day. Therefore, men and women are to serve alongside one another, in perfect equality, in both office and function. In fact, a woman cannot be "perfectly equal" if she cannot do what men do (as an office). Leadership should be determined by spiritual gifts, not by gender. I cannot now conclude that only men can serve as pastors/elders, or by my own interpretation, I am violating my premise.

I conclude that men or women can both serve as the pastor or as an elder. Otherwise, Acts 2:17-18 is violated. If I am a member of a church where a woman is the lead pastor, and I am not able to be fed, spiritually, because of my own personal history, I need to depart. But I am not going to judge a servant of the Lord by gender.

The last mile. I liken the last days to a marathon, 26.2 miles in duration. The marathon began with the outpouring of the Holy Spirit at Pentecost 2,000 years ago. The question we must ask is, "What mile are we on, now?" I suggest we are on the last mile.

The interesting thing about the term "last days" is that it has a beginning point, but the ending point is a distant time in the future, unknown to any of us. Peter established the beginning point in Acts 2 when he applied the Joel 2 prophecy to the outpouring of the Holy Spirit at Pentecost. The seed of the prophecy was planted at Pentecost; but it would take many years before women would have the courage to obey the call of God and walk alongside men rather than behind them.

Women "then" and "now." An important factor has to be considered: How did women fare 2,000 years ago compared to now? In the first century, women were viewed in ways that, compared to the modern day, would be nothing short of chauvinistic, disparaging, and discriminatory. In Judaism, the Rabbis taught the following about women:

> "Better to burn the Torah than to teach it to a woman..."[110]

> "R Eliezer says: If any man gives his daughter a knowledge of the Law it as though he taught her lechery [unbridled desire]. R. Joshua says: A woman has more pleasure in one *Kab* [the smallest of measures] with lechery than in nine *kabs* with modesty. He used to say: A foolish saint and

110 Mounce, *Pastoral Epistles*, 117.

a cunning knave and a woman ... they will wear out the world.[111]

"How does a man differ from the woman? He may go with hair unbound and with garments rent, but she may not go with hair unbound and with garments rent; ... a man may sell his daughter but a woman may not sell her daughter; a man may give his daughter in betrothal but a woman may not...; a man is stoned naked but a woman may not be stoned naked; a man is hanged but a woman may not be hanged; a man may be sold to make restitution for what he has stolen but a woman cannot be sold to make restitution for what she has stolen."[112]

In the 1st century, it was thought that women were more susceptible to being deceived than men, and women were inferior to men. The male/female relationship was described like this:

Aristotle advised his male readers on how to govern their wives because of **women's essential inferiority.** Greeks believed that a gender-based hierarchy is based on the ontological [essential nature or being] nature of

111 Herbert Danby, *The Mishna* (New York, NY: Oxford University Press, 1989), 296.
112 Ibid., 297.

women and men rather than the standards of or conventions of culture. According to Aristotle and Greek thought, the cosmic hierarchy is expressed in two genders that have mutually exclusive qualities. The perfect body is male/man, whose natural state is physical and political strength, rationality, spirituality, superiority, activity, dryness, and penetration. Meanwhile, female/women embodies humanity's negative qualities, which are physical and political **weakness, irrationality, fleshliness, inferiority, passivity, wetness, and being penetrated.**"[113] (emphasis added)

Paul's instruction in the 1st century must be interpreted within his cultural context. Women were seen as the "embodiment of humanity's negative qualities." It should not surprise us that Paul's instruction was that they should not teach a man, not usurp his authority and be silent while learning.

Let a woman learn. Paul had one very progressive instruction for women of his day. It is found in 1 Timothy 2:11, a phrase I have yet to mention:

Let a woman learn quietly with all submissiveness.
(1 Tim. 2:11 ESV, emphasis added)

113 Cynthia Long Westfall, *Paul and Gender: Reclaiming the Apostle's Vision for Men and Women in Christ* (Grand Rapids, MI: Baker Academic, 2016), 1.3.1.

In our day, our emphasis is on the phrase "... *with all submissiveness.*" I propose we have the wrong emphasis. The phrase to be emphasized is "let a woman learn." In the 1st century, women *were not allowed to learn.* As stated, women were the "embodiment of humanity's negative qualities." Jesus changed that. Mary sat at his feet while he taught. The women wept at the foot of the cross. The women were the first witnesses to the resurrection, and the first evangelists of the resurrected Christ. The Apostle Paul is actually taking a step in the same direction that Jesus led the church. In that context, Paul's instruction that a woman should learn is a counter-cultural admonition.

A 2018 report by Eileen Campbell-Reed (the first report in over 20 years), makes these conclusions based on the numbers:

- In 1960, women were 2.3% of U.S. clergy. In 2016, women are 20.7% of U.S. clergy.
- Since 2015, Roman Catholic lay ministers outnumber priests in the U.S., and 80% of them are women.
- In 2017, women remain fewer than 25% of seminary faculty and deans, and just 11% of the presidents.
- In most mainline denominations, the percentage of clergy-women has doubled or tripled since 1994.
- More women of color and fewer white women are going to seminary to earn MDivs since 2008.[114]

114 "State of Clergywomen in the U.S.: A Statistical Update," Eileen Campbell-Reed, accessed December 19, 2019, https://eileencampbellreed.org/state-of-clergy/.

How do you explain these statistics unless God is doing something new through the gifts and calling of women? It is also interesting that the last statistic mentioned is that more women of color are going to seminary than white women. Wonder why? In African American churches, women preachers are accepted but in white churches, they are not.

How did Jesus authenticate change? I liken what is happening with women today to what happened when Jesus sought to change the way the religious leaders viewed the Sabbath. Jesus healed on the Sabbath, contrary to the teaching of the religious leaders. There are many examples of this, each having the same purpose: the religious leaders' interpretation of the Sabbath was contrary to God's interpretation. Jesus did precisely what the religious leaders said was a violation of the Sabbath law—He healed on the Sabbath. One such example sums it up:

> And a man was there with a withered hand. And they asked him, "Is it lawful to heal on the Sabbath?"--so that they might accuse him. He said to them, "Which one of you who has a sheep, if it falls into a pit on the Sabbath, will not take hold of it and lift it out? Of how much more value is a man than a sheep! So it is lawful to do good on the Sabbath." Then he said to the man, "Stretch out your hand." And the man stretched it out, and it was restored,

healthy like the other. But the Pharisees went out and conspired against him, how to destroy him. (Matt. 12:10-14 ESV)

In my mind, women are much like the *sheep that fell into the pit on a Sabbath.* The religious leaders are more concerned about the "law" than the sheep. Meanwhile, the sheep perish in the ditch. The theologians of complementarianism use weighty words to describe a woman's worth and equality (see the Danvers Statement previously noted) with men; yet, their hermeneutics in interpreting Scripture will not allow them to consider anew the clear work of God in the lives of women today. As Jesus would lift the sheep out of the ditch on the Sabbath so he is lifting women out of the theological ditch the complementarians seek to keep them in. Jesus says, "How much more valuable are you than sheep!" What the serpent stole from women in the Garden, Jesus is restoring to them today.

Are we interpreting Scripture so we can line up with culture? Some say that women have been excluded from leadership (and ordination) since the time of Christ. If that were not God's will, why has it been that way for so long? In a male-dominated hierarchy, why should we expect otherwise?

One renowned leader in the SBC, Dr. Albert Mohler, President of Southern Seminary, describes it this way:

Denomination by denomination, church by church, many of the liberal denominations, first and most liberal, and then moving to others eventually came to terms with feminism and began to ordain women. ... It is now over whether or not openly gay, LGBTQ persons should also be considered on equal ground to serve as priests and ministers within the Church of England. And here's where intelligent Christians need to understand that these issues are never fully separable.[115]

Dr. Mohler later in this interview refers to this as the "slippery slope" argument. Others refer to it as "creeping liberalism."[116] That is, if a "compromise" is made in one area, it will eventually lead to another and another, eventually leading to an interpretation clearly outside the teaching of Scripture.[117] What is important to know is that according to one researcher, among weekly-attending Southern Baptists, the percentage of those who consider themselves as "biblical literalists" has never been higher; in fact, over the last twenty years, it has increased 10%.[118] And, in spite of

115 "The Briefing: Thursday, March 7, 2019," Albert Mohler, accessed May 8, 2020, https://albertmohler.com/2019/03/07/briefing-3-7-19.
116 "There is No 'Creeping Liberalism' in the Southern Baptist Convention," Ryan Burge, accessed May 22, 2020, https://medium.com/@ryanburge_82377/there-is-no-creeping-liberalism-in-the-southern-baptist-convention-3a364c3ecee.
117 "The Briefing: Thursday, March 7, 2019," Albert Mohler, accessed May 8, 2020.
118 "There is No 'Creeping Liberalism' in the Southern Baptist Convention," Ryan Burge, accessed May 22, 2020.

the fact that only 37.1% of the general public thinks homosexuality is wrong, 86% of Southern Baptists continue to believe it so. Biblical literalism among Southern Baptists has not fallen in spite of the changing views of women in ministry as Mohler's premise assumes.[119] Mohler states, "I mean by that, this quite bluntly. If you look at arguments for the ordination of women to the ministry, you are looking at arguments that require going around, indeed driving through, **very clear teachings of Scripture**" (emphasis added).

Really? "...very clear teaching of Scripture"?

With *deep respect* for Dr. Mohler, there is no Scripture that *specifically* says a woman should not be ordained. The 1984 Kansas City Resolution may have concluded it is wrong, but Scripture does not. Nor is there a specific Scripture that says a woman should not be a preacher. If you looked at the different translations of 1 Timothy 3:11, the controlling passage on whether a woman can be a deacon, some translate *gune* as wives (ESV, KJV, NLT) and others translate *gune* as women (NAS, NIV, NRS). If the teaching is so clear, why can't the translators agree on how to interpret the word? And, do we continue to deny women the equal standing that Scripture declares because we are afraid of the "slippery slope" argument? Isn't the slippery slope argument what the scribes and Pharisees used in the time of Christ to create over 400 laws to keep Jews from violating the command to rest

119 Ibid.

on the Sabbath? They created boundaries to ensure the Sabbath would not be violated, and in the process, they lost sight of God's purpose for the Sabbath.

The danger of the "slippery slope" argument. In the course of my research, I came across a periodical published by Dr. John A. Broadus, D.D., LL.D., the second president (1889-1895) of the Southern Baptist Theological Seminary[120] (of which Dr. Mohler is now the president). I quote from his periodical entitled, "Should Women Speak in Mixed Public Assemblies?":

> There is a present a strong tendency in some parts of our country to encourage women in the practice of public discourse to mixed assemblies. This connects itself, more or less, with the movements of female suffrage, though some strongly favor the one who are opposed to the other. Christian civilization has by degrees greatly elevated the female sex; and now the demand is, in many quarters, the women shall be encouraged to do, if they like, anything and everything that men do.[121]

Broadus seems quite concerned that women be "encouraged to do, if they like, anything and everything that men do." What if we

120 "John A. Broadus: 1889-1895," The Southern Baptist Theological Seminary, accessed May 20, 2020, https://archives.sbts.edu/the-history-of-the-sbts/our-presidents/john-a-broadus-1889-1895/.

121 John A. Broadus, *Should Women Speak in Mixed Public Assemblies?*, In *The Western Recorder* (Louisville, KY: Baptist Book Concern, n.d.) 1.

were to return to the place of women in Broadus' day and to his interpretation of Scripture? I have five granddaughters. I cannot imagine that it is God's will to close doors to them that are open to my three grandsons. At the time that Broadus wrote this periodical, women did not have the right to vote. It took the movement of the Holy Spirit, acting through women, to change that. Broadus' concern in this periodical was that women might *start speaking in public gatherings when men were present!* Had women followed Broadus' teaching, the suffrage movement, led by women, would never have successfully granted women the right to vote.

Broadus interprets 1 Tim 2:12, in part, in the following statement:

> A more plausible method of explaining away Paul's prohibition [of women speaking in public if men are gathered] consists in maintaining that it applied only to the peculiar ideas and manners of that time. ... But the apostle makes the same prohibition through Timothy for the churches in the region about Ephesus; and observe, he grounds his prohibition [in the passage from Timothy] upon facts connected with the Creation and the fall of Adam and Eve. Does this not absolutely forbid restricting his prohibition to a current emphasis, or to that particular age?

In other words, Broadus concludes that Paul could not be limiting his prohibition of women speaking in public to Paul's day because Paul justified his argument on Eve's fall not on Ephesus' culture.[122] Broadus goes on to conclude that women should not speak in any gathering where men might be present:

> He [Paul] says a woman must not speak in mixed assemblies, those in which men are present; because she is thus undertaking to "teach" men, to "have dominion" over them; and this is inconsistent with that "subjection" of the woman to the man which both passages enjoin, and which the Bible so often asserts. ... There is no prohibition of **feminine discourse in female prayer meetings or missionary societies. Only keep the men out.**[123] (emphasis added)

Broadus states another relevant point to 1 Tim 2:12:

> One other point. Some will say, "If we undertake to carry out such strict views, they will be found to conflict with the work which some women are

122 We have already discussed in depth why Broadus' interpretation is invalid. The mistranslation of *authentein*, the church of Ephesus, the women of Ephesus, the heresy in the church, all contributed to what Paul instructed; and, the cult of Artemis even impacted Paul's use of the fall of Adam and Eve in his reasoning.

123 Broadus, *Should Women Speak in Mixed Public Assemblies?*, 9.

almost everywhere doing as teachers of male Bible classes, as professors in co-educating colleges, and sometimes as missionary workers in foreign fields." I shall not now inquire how far these practices conflict with the apostle's prohibition. But if any of them do thus conflict, then instead of **being relied on as precedent to set aside the apostle's authority, they ought themselves to be curtailed and corrected.**[124] (emphasis added)

Where would Lottie Moon be if she had followed the interpretation of Dr. Broadus? Or any of the women that I have included in this book as examples of what God is doing through women over the years? My examples are only a sprinkle of the many God has used to His glory.

From my perspective, praise the Lord that the "slippery slope" has led us to the place we are in society and in the church. Women can vote, not only in the political arena but also in church business meetings. Praise the Lord that Broadus' interpretation that "they ought themselves to be curtailed and corrected" did not occur. Women no longer must rely on their husbands to be their voice. They speak in public, whether in society, the workplace, or the church. They have gained their voice and it can only be by the work of the Holy Spirit. How can that not be the will of the Lord?

124 Ibid., 15.

The "assigned space" for a woman is not behind a man, in silence, but beside him contributing to the work of God in His church and in the world.

Does the prophecy of Acts 2:17-18 apply in the home as well as the church? In the course of writing this book, I have thought much about the traditional view (the complementarian view) as it relates, solely, to the home. Is it possible that the traditionalist view in the home is well supported by Scripture, but the traditionalist view in the church is not? In the traditionalist view in the home, the husband is the head and its spiritual leader.[125] In Genesis 2:16, the law was given to Adam by God. Eve had not been created when the law was given to Adam. Adam apparently instructed Eve in the law, and, in fact, went beyond God's instruction by broadening His prohibition to include "to not touch" the tree (Genesis 3:3).

Many traditionalists advocate that the Fall of Adam has resulted in husbands either being passive to the point of "not present" or overbearing to the point of abusive. Wives, likewise, to the point of being doormats in submission or controlling as dominant females. The Lord changes the hearts of both through the cross; husbands love their wives as Christ loved the church and died for her (Ephesians 5:25) and wives respect and build up their husbands (Ephesians 5:33). Together, as image bearers of God, they are one flesh in every aspect of their marriage.

125 "The Danvers Statement," The Council on Biblical Manhood and Womanhood, accessed May 23, 2020.

Christ defines leadership in a way that is the opposite of the "rulership" described in Genesis 3:16. Christ's definition is founded upon a love-motivated sacrifice of a husband for his wife. In the husband's actions, the wife is likewise motivated to voluntarily "come under" her husband's love as she willingly submits to her husband. She builds him up and encourages him, by respect, admiration, and honor (Ephesians 5:22-24, 33). Submission is not as a "doormat" but rather by a willingness to follow, all the while, enabling the husband to lead. After all, without a follower, leadership is without meaning. A husband must give his wife someone to follow. He is the *initiator* in all respects, the one who has the *responsibility to take the first step*. He does what Adam did not do— take the initiative to protect, defend and stand up for his wife. Had Adam opened his mouth in protest and rebuke of the serpent, the Fall would not have occurred; at least so far as Adam's penalty—the curse upon the ground. Had Adam led, imagine the difference it would have made on a fallen world.

If we look closely at Acts 2:17-18, the prophecy actually applies *only to the church*. It does not apply in the home.

'AND IT SHALL BE IN THE LAST DAYS,' God says, 'THAT I WILL POUR FORTH OF MY SPIRIT ON ALL MANKIND; AND YOUR SONS AND YOUR DAUGHTERS SHALL PROPHESY, AND YOUR YOUNG MEN SHALL SEE VISIONS, AND YOUR

OLD MEN SHALL DREAM DREAMS; EVEN ON MY BONDSLAVES, BOTH MEN AND WOMEN, I WILL IN THOSE DAYS POUR FORTH OF MY SPIRIT And they shall prophesy. (Acts 2:17-18 NAU)

The prophecy envisions men and women walking alongside each other, not women walking behind men. There is no Scripture that would negate the clear teachings of Scripture on the traditionalist view for the relationship of husband and wife in the home, I concur with the teaching of the traditionalist so far as the home is concerned.

If one looks at the Scriptures that support the Danvers Statement,[126] each of the Scriptures included in the document applies to the home, only, with the exception of 1 Timothy 2:11-14. Yet, the Danvers Statement closes with this statement:

We are convinced that a denial or neglect of these principles will lead to increasingly destructive consequences in our families, our churches, and the culture at large.[127]

Why does the denial of the Statement's conclusions lead to "destructive consequences in ... our churches..." and the "culture at

126 Ibid.
127 Ibid.

large"? The traditionalist view upon which the Statement is based mistranslates *authentein* in 1 Timothy 2:12. A correct translation of *authentein* applies only when women are usurping, controlling, and taking over leadership in places where they do not have the spiritual gifts or the authority to do so. Applied in a correct way, 1 Timothy 2:12 acts to open the door to women in the church, thereby greatly increasing the influence of the church if for no other reason than the church will have more gifted people to draw upon in ministry. That is hardly destructive, rather it is liberating. And why is this view destructive to the "culture at large"? The culture is not impacted one way or the other about how husbands and wives relate, biblically, to one another in the home.

The Statement also includes this paragraph relative to the roles of women in the church:

> In the church, redemption in Christ gives men and women an equal share in the blessings of salvation; nevertheless, some governing and teaching roles within the church are restricted to men (Gal 3:28; 1 Cor 11:2-16; 1 Tim 2:11-15).[128]

The above quote that restricts "governing and teaching roles" to men finds its support in three passages that are given as support for the conclusion. We have already discussed 1 Timothy 2:11-15

128 Ibid.

at length. The other two passages citied in the Danvers Statement are (keep in mind these Scriptures are given to "restrict" the roles to men):

> There is neither Jew nor Greek, there is neither slave nor free, **there is no male and female**, for you are all one in Christ Jesus. (Gal. 3:28 ESV, emphasis added)

> But I want you to understand that the head of every man is Christ, the head of a wife is her husband, and the head of Christ is God... For if a wife will not cover her head, then she should cut her hair short. But since it is disgraceful for a wife to cut off her hair or shave her head, let her cover her head.... Judge for yourselves: is it proper for a wife to pray to God with her head uncovered? Does not nature itself teach you that if a man wears long hair it is a disgrace for him, but if a woman has long hair, it is her glory? For her hair is given to her for a covering. If anyone is inclined to be contentious, we have no such practice, nor do the churches of God. (1 Cor. 11:3, 6, 13-16 ESV)

Really? The basis for the complementarian view that restricts the role of "governing and teaching to men" *in the church* is Paul's

statement that women should wear head coverings in the church? That is, a head-covering is the symbol of a woman's submission to her husband and that means certain roles in the church must be restricted? I fail to see the logical connection between wearing a head covering and a women's proper role in the church.

My research of why Paul made this statement is that respectable women in the 1st century *all wore* head coverings much like Muslim women do today.[129] If a woman did not have her head covered it made a statement that she was either "available" or she was a slave. Slaves were not allowed to wear head coverings; and, if a wife did not cover her head, it was a dishonor to her husband because it told others that she was either not married or "available." One scholar explains the cultural context as follows:

> The rules on veiling—specifically which women must veil and which could not—were carefully detailed in Assyrian law... The veil served not merely to mark the upper classes but, more fundamentally, to differentiate between "respectable women and those who were publically [sic]available. That is, use of the veil classified women according to their sexual activity and signaled to men which women were under male protection and which were fair game.[130]

129 Westfall, *Paul and Gender*, 27.
130 Ibid., quoting Leila Ahmed, *Women and Gender in Islam: Historical Roots of a Modern Debate* (New Haven, CT: Yale University Press, 1992), 14-15.

In Luke 7, we find the familiar story of the woman who washed Jesus's feet with her hair. I have often wondered why she "forgot" to bring something to dry his feet since she brought the alabaster jar of perfume to anoint his feet (Luke 7:37). Why did she not use her head covering for that purpose? Surely her head covering would have sufficed; and, it was far more effective than her hair to dry the perfume and her tears. After all, all women of the 1st century were expected to wear a head covering (1 Cor. 11:13-14). I propose that she was not wearing a head covering because she was not a "respectable" woman. She was single, "available," and made her living on the street corner. The Pharisee believed Jesus (Luke 7:39) should have known that. Why? *Because women without head coverings in the 1st century were like women on "The Block" in Baltimore. They sold their bodies for a living.*

Paul's instruction in 1 Corinthians 11 is intended to teach that a husband is the head of his home. His wife is to respect him and honor him (Ephesians 5:33), in both the home and in the church. When she failed to wear a head covering in public, in church or otherwise, she disrespected him and declared that she was available. That was a disgrace to her husband. It was also a disgrace to the church only so much as it related to appropriate and inappropriate behavior, and dress, for women in the church. *But that has nothing to do with restricting the role of women in the church whether in the use of their spiritual gifts or the role of leadership as the Danvers Statement proposes.*

125

A number of years ago, a homeless man and his female companion began attending our church. We had started a ministry in an area where the homeless gathered and one of our members invited them to church. They both had a history with drug addiction. We brought the love of Jesus to them, and for a time, they regularly attended the church. However, the female was attired in a way that looked as if she had just stepped off "The Block." I requested one of our ladies to discreetly chat with her, without judgment, and help her with clothes that "covered" a bit more. By the grace of God, the young lady received her counsel. Sometime later, the two were arrested for some reason and I never saw them again. My point? I would not have offered her a position in leadership or a position to teach a Sunday School class. The reason, however, was not because she was female. She wasn't spiritually ready. She was a new believer, and the transforming power of the gospel had not sufficiently done its work in her life. Teaching or leadership for her was out of the question, at least for the moment.

Paul is saying the same thing to the women in the church at Corinth. To not wear a head covering was to be inappropriately dressed. That was a disgrace to her husband and a disgrace to the church. It communicated an inappropriate message, and Paul wanted to ensure that women did not communicate that disparaging message upon their husbands or upon the church. But that was not the same thing if, for example, Priscilla taught at church

on Sunday; or if she served as a deaconess in Cenchrae or in Rome (Rom 16:1-2), provided, of course, she wore her head covering.

What the Danvers Statement concludes is that the reason Paul restricted teaching to men was because women were disqualified on the basis of gender, not on the basis of spiritual immaturity or inappropriate behaviors.

I return to the periodical written by John A. Broadus entitled *Should Women Speak in Mixed Public Assemblies?* As you read his statement, notice that Broadus' argument is actually founded on culture, not on the inherent nature of womanhood:

> The same consideration applies when the prohibition is likened to his direction in chap. 11 that a woman must not appear in the public meeting without a covering on her head. We are told that this applied simply to the ideas and customs then prevailing. Let us not be so sure that such is the case. In point of fact, almost all Christian women seem to have a feeling that the apostle's direction applies to them, for they very rarely fail to wear in religious assemblies some form of head covering, which in the mutations of fashion has sometimes been vastly more diminutive than at present, but is never discarded.[131]

131 Broadus, *Should Women Speak in Mixed Public Assemblies?*, 7-8.

Notice, "almost all Christian women seem to have a feeling that the apostle's direction applies to them...[and so they wear a hat]." Actually, my wife nor any of the women in our church wear a hat. In my entire life, I cannot remember a time when *all* women wore hats as Broadus states. The only time I have ever seen all the women wearing hats was while watching the Kentucky Derby or the Preakness on TV. In the 21st century, "all Christian women" do not have the feeling that they should wear a hat. In the 1st century, women did. In Broadus' day in the 19th century, they apparently did as well; but not the 21st. My point is that Paul is making a statement that is founded upon how women behaved in 1st century society. Broadus is doing the same – it's just 1900 years later. It is not by divine design, i.e., the nature of women, or divine instruction, that women wear hats. It is culture that tells a woman if she should wear a hat, i.e., like the Kentucky Derby Phenom. Culture should not define how we interpret Scripture.

Lastly, *all* of the Scripture references in the Danvers Statement, other than 1 Timothy 2:12 and possibly 1 Corinthians 11:2-16, refer to the relationship of husband and wife, *in the home*. They do not refer to the relationship of men to women in the church. Here is the list of all the Scriptures referenced in the Danvers Statement should you wish to read them for yourself: Genesis 2:16-18, 21-24; 1 Corinthians 11:7-9; 1 Timothy 2:12-14. Ephesians 5:21-33; Colossians 3:18-19; Titus 2:3-5; 1 Peter 3:1-7. How can we restrict "governing and teaching roles within the church to men" on the

basis of passages relevant for the home, not the church? It seems to me that the "clear teaching of Scripture" is being restricted, once again, for the "ordinary people." The hermeneutical oddities are obscuring the clear meaning of the word of God. To list Scripture passages for the home as support for restricting the role of women in the church seems quite an oddity to me.

I must conclude, with respect to my learned brothers, the complementarian view continues to apply to the home; but to extend it to the church is a stretch that I do not see Scripture supports. Further, the application of the prophecy of Joel 2/Acts 2 demands that it not extend to the church.

Closing thoughts. In the opening chapters of Acts, we find Peter and the apostles energetically preaching the Good News of Jesus. They are defiant against the high priest and his associates (Acts 5:17). They are tossed in jail because of their testimony of Jesus. During the night, an angel of the Lord frees them, and directs them back to the temple: "Go, stand and speak to the people in the temple the whole message of this life" (Acts 5:20). The leaders are in a quandary about what to do with the disciples. A wise Gamaliel gives his counsel to the leaders:

> And he said to them, "Men of Israel, take care what you are about to do with these men. For before these days Theudas rose up, claiming to be somebody, and a number of men, about four hundred, joined

> him. He was killed, and all who followed him were dispersed and came to nothing. After him Judas the Galilean rose up in the days of the census and drew away some of the people after him. He too perished, and all who followed him were scattered. So in the present case I tell you, keep away from these men and let them alone, **for if this plan or this undertaking is of man, it will fail; but if it is of God, you will not be able to overthrow them. You might even be found opposing God!**" So they took his advice... (Acts 5:29-39 ESV, emphasis added)

Are the women in the Church much like the disciples in Peter's day, commanded to be silent by the religious leaders? Perhaps, the counsel of Gamaliel is worth noting: *"If this undertaking is of man, it will fail; but if it is of God, you will not be able to overthrow them. You might even be found opposing God!"*

Crushing the head of Satan – **to the glory of the Only Begotten Son, Jesus.** I have contemplated this question: *How would God land his bruises upon the head of the serpent in the end-of-days?*

> And I will **put enmity Between you and the woman**, And between your seed and her seed; **He shall bruise you on the head**, And you shall bruise him on the heel." (Gen. 3:15 NAU, emphasis added)

A *bruise* is not a fatal blow. A nagging wound, perhaps, but not fatal. How might Christ inflict his wounds upon the prince of darkness in the end-of-days? Of course, the cross is His ultimate bruising-weapon; and, the resurrection declares who is wielding the weapon—God, Himself. But the after-cross blows, what about those? Ever wonder why it was the women at the foot of the cross and not the disciples (save John)? Why the women were the first to the tomb? Why the women were the first evangelists telling of the resurrection (Luke 24:8-9)? And, why the women were present at Pentecost and even heard Peter speak about their role in fulfilling the prophecy of Joel 2:28? Ever wonder why, in spite of 1 Timothy 2:12, that throughout the history of the Church, women have never, as John MacArthur advocated in our opening chapter, "gone home"?

Do you suppose that God's plan is to use the descendants of the one who *took the first bite as* a primary instrument in His wounds upon the serpent? What more effective bruise could be inflicted than to use the hand of the one who reached for the forbidden fruit that mournful day in the Garden? What more humiliating blow could be struck upon Satan's head than to use the descendants of the one who took the first bite? Those who have born the pain, the abuse, the humiliation of always "walking behind"—would it not be like the Lord to redeem a woman's "bite of the forbidden fruit" in the first days, by using her to be His "bruising" hand in the last days?

It is fallacious to think that God will not use the "Eves" among us to bring humanity out of the realm of darkness into the realm of light solely because they are of the wrong gender:

> For He rescued us from the domain of darkness, and transferred us to the kingdom of His beloved Son, in whom we have redemption, the forgiveness of sins. (Col. 1:13-14 NAU)

How do you explain the explosion in the modern-day of ministry by the female gender? I see Jesus pouring "gas on the fire" through the ministry of women in the modern-day. After all, "vengeance is mine, I will repay" says the Lord (Romans 12:19). As we near the return of Christ, women (and men) will deepen that wound and prepare Satan for his 1,000-year imprisonment at the hands of the Almighty. *Eve took the first bite.* She will certainly have *no less than* an equal role in throwing Satan in his prison since he threw her into hers. It is not that the work of man is being minimized. It is that the work of woman has been made one with man, as male and female walk alongside one another to the glory of the Only Begotten. To this end, they will cast the prince of darkness into an abyss that will incarcerate him by the will of God:

> And he laid hold of the dragon, the serpent of old, who is the devil and Satan, and bound him for a

thousand years; [3] and he threw him into the abyss, and shut *it* and sealed *it* over him, so that he would not deceive the nations any longer.... (Rev. 20:2-3 NAU)

To the glory of God...

• • •

***Crushing the head of the Serpent...* a final example of a woman used by Christ:**

We close with the story of **Catherine Booth**, compelling preacher and co-founder of The Salvation Army. Catherine was raised in Victorian England, her mother the model of Methodist piety. Before the age of 12, Catherine had read the Bible cover-to-cover eight times. In her teenage years, she suffered from a spinal curvature and was forced to lay in bed months at a time. During this period, she read voraciously, particularly the works of Charles Finney and John Wesley.

When people suggested that a woman's place was in the home, she wondered if the Christian church,

which preached a liberating gospel to both men and women, could keep people from expressing their manifold ministry gifts. **She eventually concluded that "a false interpretation of Paul's comments about women keeping silent in church had resulted in 'loss to the church, evil to the world, and dishonor to God'"** (emphasis added).

After meeting and marrying William Booth, a young preacher, she shared with him her convictions about women preaching. He replied, "I would not stop a woman preaching on my account; but neither would I encourage her to begin."

Her book, *Female Ministry,* soon followed as she made a powerful defense of American Phoebe Palmer's holiness ministry. Her argument was based on "absolute equality of men and women before God." She acknowledged that the Fall has put women into subjection, as a consequence of sin; but to leave them there, she said, was to reject the Good News of the gospel, which proclaimed that the grace of Christ had restored what sin had taken away. Now all men and women are one in Christ.

In responding to her critics, she asked, "If the Word of God forbids female ministry, we would ask how it happens that so many of the most devoted handmaidens of the Lord have felt constrained by the Holy Ghost to exercise it?... The Word and the Spirit cannot contradict one another."[132]

132 *Christian History* Magazine Editors, *131 Christians Everyone Should Know*, 296-299.

Bibliography

Aherne, Cornelius. "Epistles to Timothy and Titus." *The Catholic Encyclopedia*, Volume 1. New York, NY: Robert Appleton Company. Access May 17, 2020 from New Advent, https://www.newadvent.org/cathen/14727b.htm.

Ahmed, Leila. *Women and Gender in Islam: Historical Roots of a Modern Debate*. New Haven, CT: Yale University Press, 1992.

AnGeL Ministries. "About Anne Graham Lotz," Accessed May 9, 2020. https://www.annegrahamlotz.org/about-anne-graham-lotz/about/.

Beck, James R., ed. *Two Views on Women in Ministry*, Revised Edition. Grand Rapids, MI: Zondervan Publishing, 2005.

Belleville, Linda. *Women Leaders and the Church: Three Crucial Questions*. Grand Rapids, MI: Baker Books, 2000.

Bowler, Kate. *The Preacher's Wife: The Precarious Power of Evangelical Women Celebrities.* Princeton, NJ: Princeton University Press, 2019. Kindle edition.

Boyd, Lois A., and R. Douglas Brackenridge. *Presbyterian Women in America: Two Centuries of a Quest for Status.* Westport, CT: Greenwood Press, 1996.

Broadus, John A., *Should Women Speak in Mixed Public Assemblies?* In *The Western Recorder.* Louisville KY: Baptist Book Concern, Inc., n.d.

Burge, Ryan. "There is No 'Creeping Liberalism' in the Southern Baptist Convention," Accessed May 23, 2020. https://medium.com/@ryanburge_82377/there-is-no-creeping-liberalism-in-the-southern-baptist-convention-3a364c3ecee.

Butler, Alban, ed. *The Lives of the Fathers, Martyrs, and Principal Saints.* Whitefish, MT: Kessinger Publishing, 2007.

Campbell-Reed, Eileen. "State of Clergywomen in the U.S.: A Statistical Update," Eileen Campbell-Reed. Accessed December 19, 2019, https://eileencampbellreed.org/state-of-clergy/.

Clifford Larson, Kate. *Bound for the Promised Land: Harriet Tubman, Portrait of an American Hero.* New York, NY: Ballantine Books, 2004.

Christian History Magazine Editors, *131 Christians Everyone Should Know.* Nashville, TN: Holman Reference, 2000.

The Council on Biblical Manhood and Womanhood. "The Danvers Statement," Accessed May 23, 2020. https://cbmw. org/about/danvers-statement/.

Danby, Herbert. *The Mishna*. New York, NY: Oxford University Press, 1989.

DeRusha, Michelle. *50 Women Every Christian Should Know: Learning from Heroines of the Faith*. Grand Rapids, MI: Baker Books, 2014. Kindle edition.

Easton, Matthew George. *Easton's Bible Dictionary*. New York, NY: Harper & Brothers, 1893.

Flowers, Elizabeth H. *Into the Pulpit*. Chapel Hill, NC: The University of North Carolina Press, 2012. Kindle edition.

Gingrich, F. Wilbur. *Shorter Lexicon of the Greek New Testament*. 2nd Edition. Chicago: University of Chicago Press, 1983, BibleWorks. V 10.

Gromacki, Gary. "The Spiritual War for Ephesus." *Journal of Ministry and Theology* 15, no. 2 (Fall 2011): 77-131.

Lea, Thomas D., and Hayne P. Griffin. *1, 2 Timothy, Titus: An Exegetical and Theological Exposition of Holy Scripture (The New American Commentary)* Volume 34. Nashville, TN: Broadman & Holman Publishers, 1992.

Louw, Johannes, and Eugene Nida. *Greek-English Lexicon of the New Testament: Based on Semantic Domains*, Volume 1. New York, NY: United Bible Societies, 1996. Electronic edition.

Mohler, Albert. "The Briefing: Thursday, March 7, 2019," Albert Mohler. Accessed May 8, 2020, https://albertmohler.com/2019/03/07/briefing-3-7-19.

Mounce, William D. *Pastoral Epistles: World Biblical Commentary*, Volume 46. Dallas, TX: Word, Inc., 2000.

Piper, John. "Is It Wrong for Men to Listen to Female Speakers?" Desiring God. Accessed November 2, 2019, https://www.desiringgod.org/interviews/is-it-wrong-for-men-to-listen-to-female-speakers.

Reddish, M. G. "Ephesus." In *Holman Illustrated Bible Dictionary*. Nashville, TN: Holman Bible Publishers, 2003.

The Southern Baptist Theological Seminary. "John A. Broadus: 1889-1895," Accessed May 20, 2020. https://archives.sbts.edu/the-history-of-the-sbts/our-presidents/john-a-broadus-1889-1895/.

Steinem, Gloria, Phyllis Chesler, and Bea Feitler. *Wonder Woman*. New York, NY: Holt, Rinehart and Winston and Warner Books, 1972.

Sullivan, Regina D. *Lottie Moon: A Southern Baptist Missionary to China in History and Legend*. Baton Rouge, LA: LSU Press, 2011. Kindle edition.

Thomas, Dalton and Joel Richardson. "Sheep Among Wolves: Volume One," YouTube. Accessed November 23, 2019, https://www.youtube.com/watch?v=Ndf8RqgNVEY.

Tyson, John R, ed. *Invitation to Christian Spirituality: An Ecumenical Anthology.* New York, NY: Oxford University Press, 1999.

Westfall, Cynthia Long. *Paul and Gender: Reclaiming the Apostle's Vision for Men and Women in Christ.* Grand Rapids, MI: Baker Academic, 2016.

Women's Missionary Union. "About MMU," Accessed May 23, 2020. http://www.wmu.com/?q=article/national-wmu/about-wmu.

YouTube. "John MacArthur Beth Moore Go Home." Accessed May 17, 2020. https://www.youtube.com/watch?v=NeNKHqpBcgc.

Made in the USA
Columbia, SC
05 December 2023

27834012R00090